FOLKESTONE
THROUGH TIME
Alan F. Taylor

AMBERLEY PUBLISHING

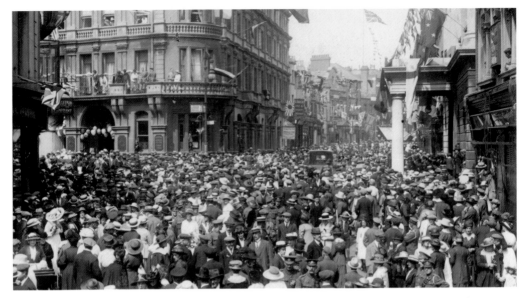

The crowd seen here are dispersing following a Peace Parade in July 1919, in Guildhall Street at the junction with Sandgate Road. The large building with the balconies is the Queens Hotel while the porch on the right-hand side belongs to the Town Hall.

I dedicate this book to my wife, Eileen for all her patience and understanding during the period of time I have been working on the publication. Very special thanks to my son, Andrew, for writing the introduction and for all his support, advice and proof reading.

First published 2009

Amberley Publishing Plc
Cirencester Road, Chalford,
Stroud, Gloucestershire, GL6 8PE

www.amberley-books.com

© Alan F. Taylor, 2009

The right of Alan F. Taylor to be identified as the
Author of this work has been asserted in accordance with the
Copyrights, Designs and Patents Act 1988.

British Library Cataloguing in Publication Data.
A catalogue record for this book is available from the British Library.

ISBN 978 1 84868 359 4

Typesetting and Origination by Amberley Publishing.
Printed in Great Britain.

Introduction

The purpose of this book of photographic reminiscences is, as is the case with most books of this genre, to present the reader with images of time and space that chart both transition and stability. The passage of time holds deep resonance for most people, as both we and our surroundings change and adapt with time. Yet we also hold a profound fascination with space, or more particularly with place. Whether we were born here, or have arrived here at some other time in our lives, it is likely that most people reading this book, will, at some point, have called the place that is Folkestone 'home'.

Now, as the passage of time steers its course unrelentingly there are those for whom the Folkestone of 'now' is a pale comparison to the Folkestone of 'then'. And similarly readers of a younger age or those who have arrived here from other places may look upon the Folkestone of old as something strange and archaic. However although both young and old may relate differently to the images of this town through the ages there is one common unifying factor, and that is the sense of place. And it is that function which the illustrations in this book hope to perform.

Almost a hundred old photographs taken from the author's collection show a number of places in Folkestone in times gone by, and by comparison these are matched with photos taken at the present time. It is hoped that by a simple cross-section of old and new imagery we may get a sense of the passing of time and the effects, sometimes sad, that they have had upon the shape and heart of the town. Similarly the reader may also view images of places that have remarkably remained unchanged, or even of places that though visually and structurally very different have nonetheless retained their essence, and may indeed have been enhanced.

Change and the passing of time do not necessarily mean entropy and decay. Although we may nostalgically look upon seemingly more peaceful and less polluted times we may still marvel at the technological wonders that have transformed our society so much. Likewise though we may lament the passing of those quaint little back streets and alleys that made up the old-harbour quarter of Folkestone, we might similarly muse upon the advantages of living in a society today that seeks to provide adequate housing for the benefit of all and the eradication of squalor. And of course we can take delight in remembering those times when butchers hung their uncovered meat from the shop front, when children could play unhindered in the streets and when crossing the road meant only avoiding horses and their 'produce'! Yet still we can appreciate our age of universal health care, proper sanitation, and ease of travel, amongst many other things.

Perspective here plays an important part in this book. Not only the perspective of our position in the 'here and now' looking back to the 'there and then' but also photographically. Landscapes and more distant views, some presented here, show the effects of housing developments and the loss of open spaces. Likewise it is sometimes the case that some areas are more wooded today, though in other instances the opposite is also true. In fact sometimes the recent construction of new buildings or the planting of new trees makes it difficult for the modern photographer to take a picture from the exact spot where his Edwardian predecessor would have stood. And let's not forget the adjustment to perspective that technology has provided. Digital photography

allows many attempts at the same shot and grants the photographer the luxury of instant results, and its corollary, instant editing, whereas the photographers of old had to carefully plan each photograph and painstakingly establish the picture that they wanted to take. Now if an unwanted or passing obstruction crosses the lens at the crucial juncture one may either delete the unwanted photograph or simply try again. Imagine the frustration that a photographer must have felt when taking a picture meant placing heavy and non-reusable photographic plates into their camera! Once again though, we return to perspective, many Edwardian photos were taken using old plate cameras which had wider angle lenses to those in use today and consequently this much can be seen by comparing the photographs old and new.

Folkestone, and the settlements that occupied the place long before it was ever so named, has a history going back well over two thousand years. It has been the home of ancient Celtic Britons, Romans, Saxons and Normans. It has produced its own Saint (Eanswythe) and one of the most influential figures in medical history (William Harvey). However it is beyond the remit of this book to cover in any kind of detail the long and fascinating history of the town, and as the primary source of material for this compilation is photographic we should therefore limit the outline of the town's history to cover only the era of photography.

Much of its history and its development was connected to its relationship to the sea and it is no small coincidence that the coming of the railway and the subsequent development of the harbour into a cross-channel port heralded a new era in the story of the town. In 1843 the railway came from London and the viaduct that crosses the Foord valley was built. This was followed by the purchase of the harbour by the South Eastern railway that succeeded in transforming the ailing harbour into a successful cross-channel port. The significance of these events can be best registered when we note that between 1831 and 1881 the population grew a staggering six times, from approximately 3000 to over 18,000. This was an enormous rate of growth when compared to the population stability of the previous centuries.

The arrival of the railway and the development of the harbour instantly increased Folkestone's potential. Before long large and luxurious hotels were being built along with a great many other amenities that were needed to cater for the upper echelons of society that the town was hoping to accommodate. Through the Victorian and Edwardian years Folkestone was a resort specifically patronised by the elite of society, including aristocracy, royalty, politicians, the gentrified classes and many representatives of art and literature such as Charles Dickens, H.G. Wells and George Bernard Shaw.

The First World War was to change Folkestone however, with an enormous influx of refugees arriving and the use of the Harbour as a prime military embarkation point, the town was forced to rapidly adjust. Following the cessation of conflict the heyday of aristocratic holidaymaking at the seaside had gone for good, continental vacations were now the fashionable thing to do for those who could afford it. Therefore, between the wars, Folkestone once again had to rejuvenate itself and thus it became a resort that would appeal to middle-class families and not just the affluent.

Following World War Two and the damage caused by seventy-seven air raids and six VI attacks, Folkestone yet again had to rebuild and re-design itself in order to continue in its

function as a resort for holidaymakers and day-trippers. Much has happened to the town in the period since 1945; extensive rebuilding programmes and the expansion of residential and light-industrial areas, the building of the M20 and the Channel Tunnel, have all meant that Folkestone has undergone several major changes. And now, in the dawning years of a new millennium, Folkestone is equipped with a high speed rail link to London promising travel times of less than an hour, and once more, with the philanthropic investment of Roger de Haan, it appears to be undergoing another change of guise, as the town seeks to reinvent itself as a hub for the arts and high culture.

So this book provides the reader with a yardstick by which to measure the changes that have occurred overtime to Folkestone. We may marvel at oddities, antiquities and monstrosities. We will no doubt pass some personal judgements on whether some of the changes have been for better or for worse. But we may also simply take delight in undergoing a nostalgic tour of our town from the Little Switzerland Camp site to the lower Sandgate Road, for it is an endlessly fascinating and contrasting place. And in the ultimate act of speculation, irrespective of how we may view the changes that have occurred to the town over the years, we may consider what the town may look like in the year 2100, or how our 'improvements' may be judged by our own successors and descendents. And who knows but such speculations may encourage the reader to try not to take their town for granted and may lead to a more active involvement in those movements concerning its future. Whatever the reader's conclusions, we entrust this volume to you for your enjoyment.

Andrew Taylor

Alan F. Taylor

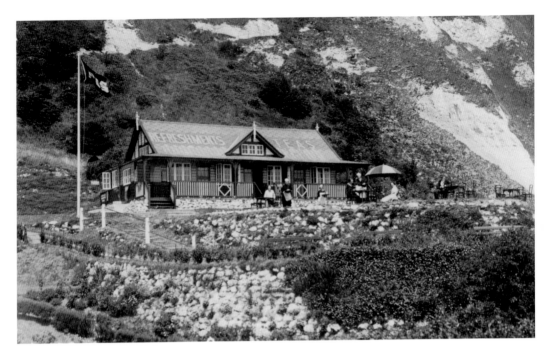

The Warren Tea Chalet.

The tea chalet was erected and the gardens were laid out c.1922. One can take the footpath leading to the top of the cliffs and at the summit is the 'Valiant Sailor'. Turning right to the edge of the cliff a zigzag path takes you down to the chalet. This area was known as 'Little Switzerland.' The beautiful tea chalet was closed during the Second World War, when it fell into disrepair and finally burnt down. The new tea chalet seen here was constructed in 1960 and the small camping and caravan park was developed.

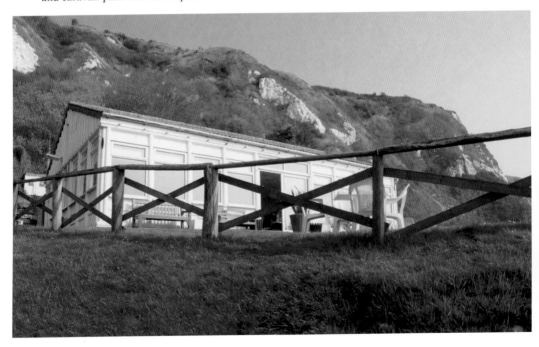

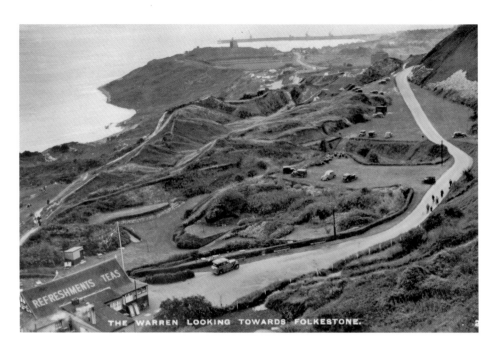

THE WARREN LOOKING TOWARDS FOLKESTONE.

The Warren, looking towards Folkestone.

The gardens were laid out in 1922 and the tea chalet was erected. The photograph was taken from the zigzag path; taking in views of the East Cliff, Martello Towers and Harbour Pier. The present day picture shows the new tea chalet, which is somewhat covered with vegetation, and also the camping and caravan park.

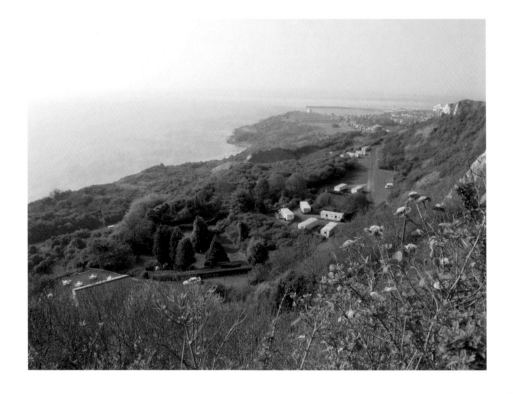

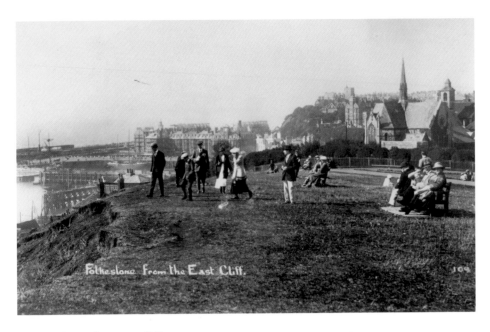

Folkestone from the East Cliff.

A View from the East Cliff.

This corner of grass on the East Cliff is locally known as 'The Triangle'. In this 1920s view one can see the branch line to the harbour station, the wooden swing bridge, and Royal Pavilion Hotel. The Hotel was designed by William Cubitt and built by the South Eastern Railway Company. Building commenced in 1843 to coincide with the coming of the railway. The Royal Pavilion Hotel was demolished between 1981 and 1982 to make way for the Grand Burstin Hotel, formerly Burstin Motel.

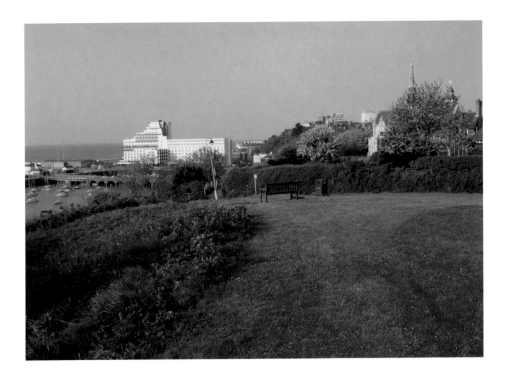

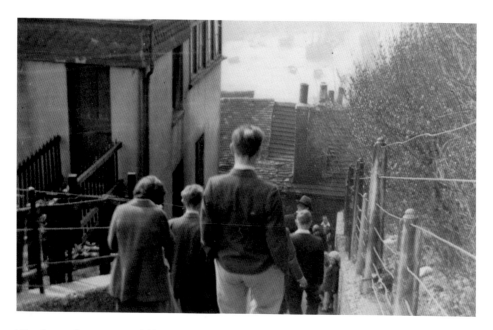

The Steps from East Cliff to the Stade.

This photograph taken in 1923 shows the steps leading from the East Cliff to the outer harbour and Stade, it goes under the buildings at the bottom of the picture into East Street. It's interesting to note in the present day picture that the building on the left has gone, as have the buildings in East Street. The old buildings in East Street were demolished by the council in 1935 to make way for the houses seen here which form part of the Stade.

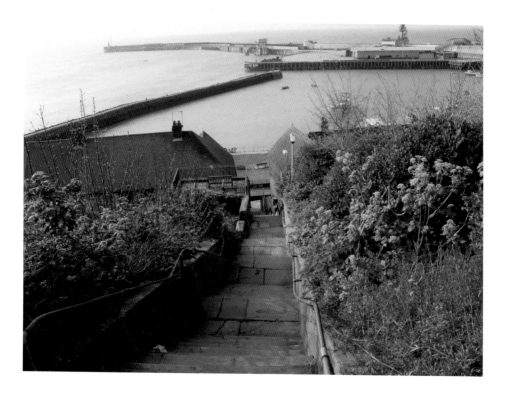

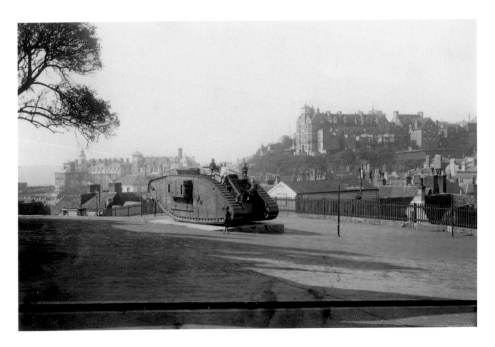

The Durlocks.

On 29 July 1919 this First World War tank was presented to the town by Sir E. Swinton, who had played a key role in its invention. The expansive Royal Pavilion Hotel can be seen in the far distance and also the 'Shangri-La' at the end of Bayle Parade. On the right-hand side are the houses in North Street. Today the Grand Burstin Hotel dominates the scene while the tank was cut up for scrap during a salvage drive in the early part of the Second World War. The houses in North Street were damaged during the Second World War and subsequently demolished in the 1950s to make way for a block of flats.

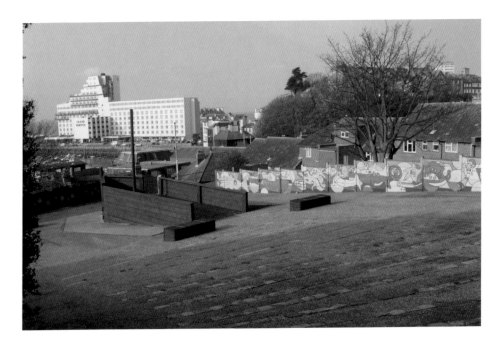

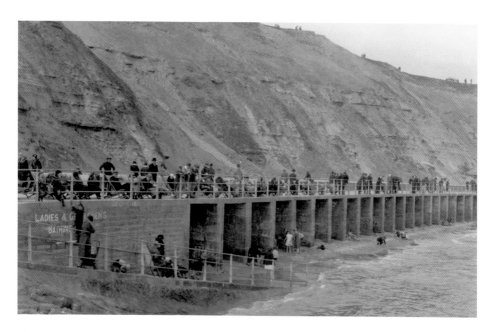

The East Cliff Sands, looking east.

In 1924 Lord Radnor gave the East Cliff area to the town in order to extend the amenities. In the late 1920s this promenade was erected and the rocks were cleared away to make a sandy beach and leisure area. The promenade was replaced by Coronation Parade in 1935, and the building at the foot of the cliffs is one of Southern Water's pumping stations, completed in 2000, which includes a terrace café.

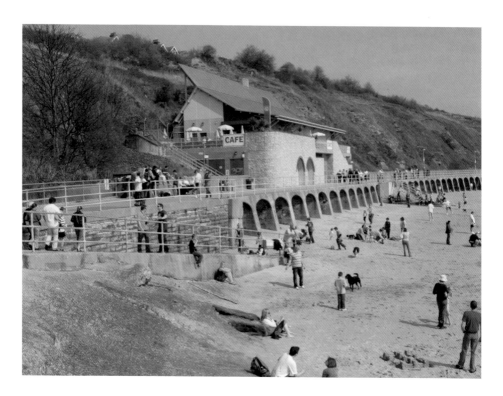

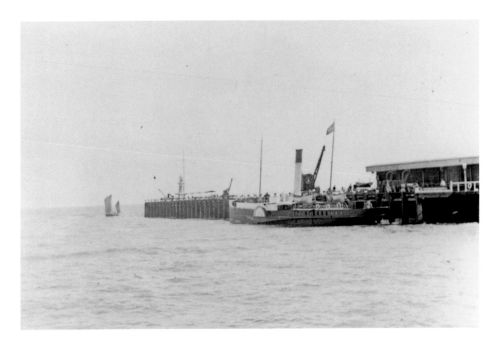

The New Low Water Pier.

This wooden trestle pier was constructed in 1861 to handle the larger steamers that had previously encountered tidal problems. It also enabled the South Eastern Railway Company to have regular sailings to Boulogne. On 1 March 1876 the railway was extended onto the new pier, it can be seen on the right-hand side of the picture. The paddle-steamer moored alongside is one of eight which the SERC had built in the 1840s. The present day photograph shows the disused run-down pier, with its extension, that was completed in 1905.

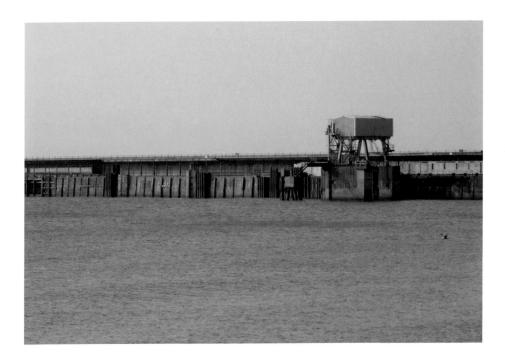

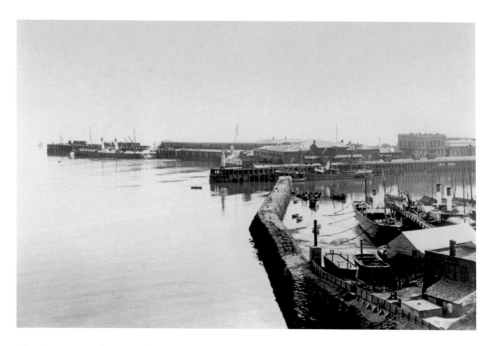

The Outer Harbour and Pier in the 1890s.

One of the two-funnel paddle-steamers seen here bow in is moored alongside the low water pier. Before the low water pier was built the steamers used the south quay in the outer harbour. In this picture a cargo ship can be seen moored alongside it. On the right-hand side of the picture in the foreground can be seen the South Eastern Railway Company's Marine Workshops. Today's picture shows the run-down harbour now owned by Roger de Haan waiting for redevelopment.

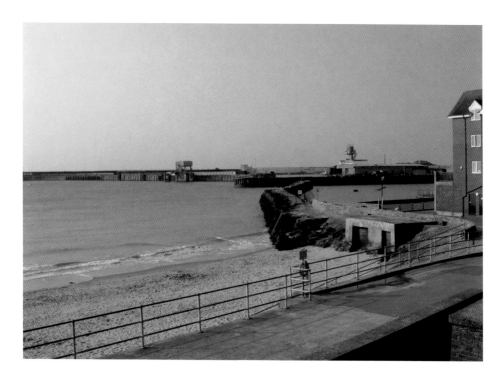

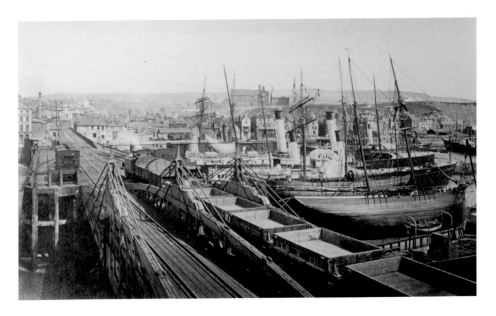

The Harbour Branch Line.

One of the Cudworth-designed 0-6-0 locomotives of 1877 is crossing the swing bridge with a train of empty wagons *c.*1882. The after-saloon of the paddle steamer *Napoleon III* is nearest to the camera, whilst beyond can be seen two sailing vessels, *Julia* and *Hannah*, followed by the paddle steamer *Alexandra*, built by Samuda Bros. in 1864, and finally the P.S. *Duchess of Edinburgh* built in 1880 by J.& G. Thomson. Today the harbour branch line is closed, and is intended to be demolished to convert the harbour into a yacht marina.

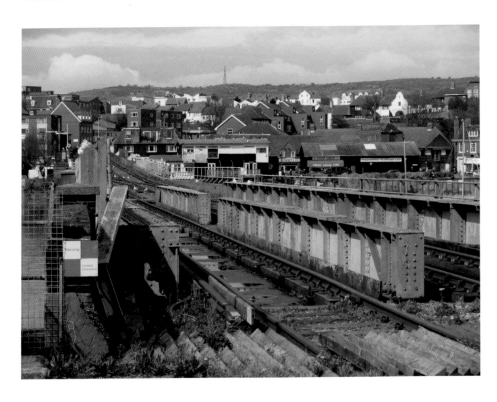

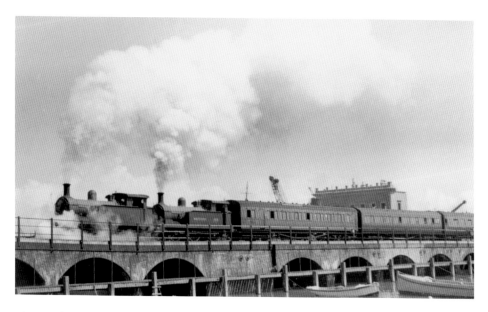

The Harbour Branch Line.

This line from Folkestone Junction station to the harbour has a 1 in 30 gradient. To climb this steep incline the use of three or four 0-6-0 tank engines was necessary. The plumes of steam were a familiar sight for the locals. Seen here is a pair of Stirling tank engines dissipating white steam across the inner harbour in the summer of 1949. On Saturday 14 March 2009 this Britannia class engine the *Oliver Cromwell* made a nostalgic run down and up the line twice. It was the last steam train to travel on the line before its closure.

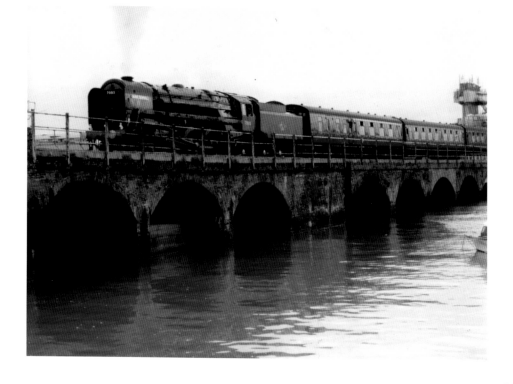

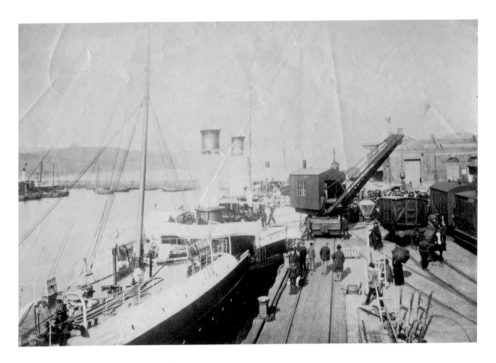

The South Quay, Outer Harbour.

A busy scene on the south quay with the arrival of the Boulogne boat *Mary Beatrice* in the 1890s. It's interesting to note the steam crane unloading a wooden container behind which can be seen the passengers coming ashore, making their way to the harbour station to catch the boat train to London. The run-down south quay as seen today is awaiting redevelopment.

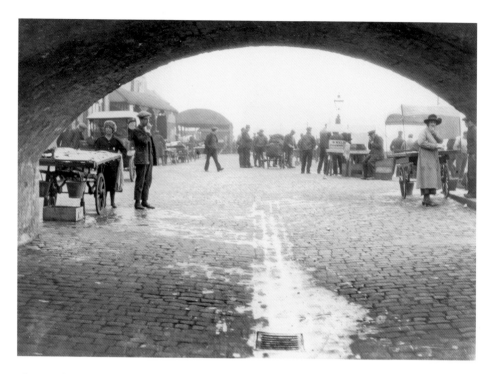

The Stade and Fish Market.

An unusual view looking through the railway arch. The Stade is thronged with fish-hawkers and fishermen going about their daily work on 11 May 1923. The barrow on the extreme left by the arch was run by Mrs Waller, whilst beyond can be seen fish sheds Nos 1 and 2. Sadly the fishing industry is in steep decline and there are currently only seven boats fishing out of the port employing a total of twenty men including the shore-based staff. The remaining fish shed No.1 was converted into a fish shop, which opened on 11 December 1985 by Folkestone Trawlers Ltd. It is currently the only wet fish outlet on the Stade.

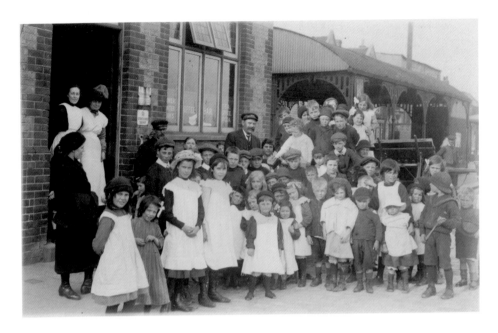

Fishermen's Bethel.

The fishermen's children posing for the camera are seen here outside the Bethel. The gentleman in the centre at the back with a moustache and peeked cap is Captain J. Nicks who ran the Bethel from 1912 to 1925. On Armistice Day 1940, the Bethel was demolished during a lunchtime attack by some hit-and-run Messerschmitt 109s. Skipper Oldman, his wife and daughter Violet, were trapped in the wreckage. Some fishermen in the Bethel at the time of the raid, were saved by taking shelter under the billiard table. The Bethel was not re-built. The site is now occupied by kiosks and public toilets, while fish shed No. 1 has been transformed into a fish shop.

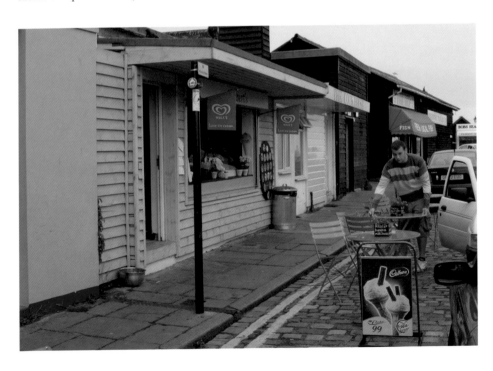

The Stade.

Fish shed No.3 and the sprat nets form a backdrop for these two fishermen posing for the camera. Mr Arthur Popham from Sandgate, a friend of the writer H.G. Wells, took this private photograph on 16 February 1899. With the absence of fish shed No.3 in the present-day picture one can see the houses and Ship Inn which were built in the mid-1930s.

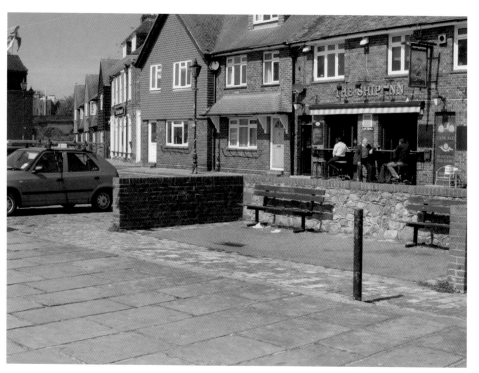

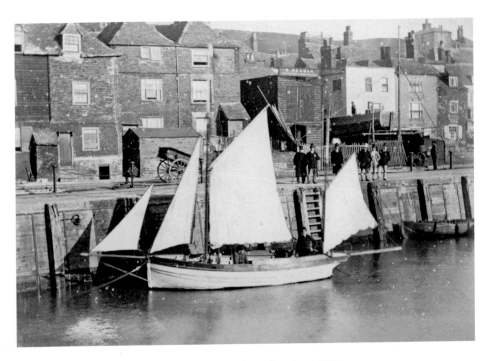

A View of the Stade from the Outer Harbour in the 1870s.

The sign on the weather-boarded building between the sails on the fishing vessel proclaims 'M. Redman, Shipwright & Boat Builder'. To the left of this can be seen a fishing lugger either being built or repaired. All these buildings were demolished during the slum clearance in 1935 and replaced with the buildings seen in this present day picture.

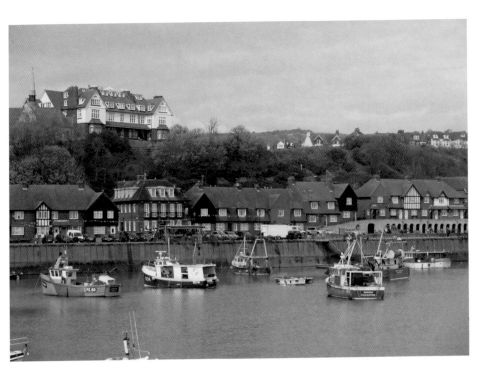

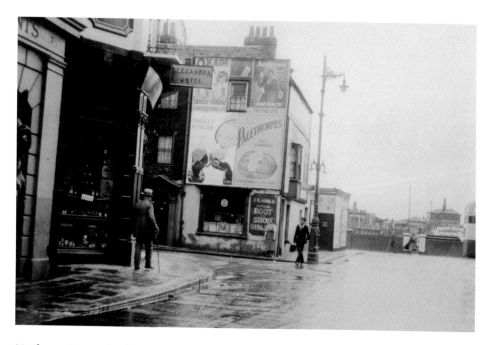

Harbour Street, looking towards the Inner Harbour c.1925.

The building on the extreme left is occupied by W. Scrivener, Coal, Coke and Firewood Merchants, it is followed by the Alexandra Hotel. The building festooned with advertisements is the premises of William Fidge, Bootmaker. The building had in the 1850s been occupied by W. Tiffen, Bookseller, Printer and Stationer. Mr Tiffen published five illustrated guidebooks for Hythe, Sandgate and Folkestone between 1816 and 1854. These buildings were destroyed by a parachute mine on 18 November 1940. The aspect today is much more open. The ground in front of Chummy's seafood stall is used on Sundays for a farmers' market.

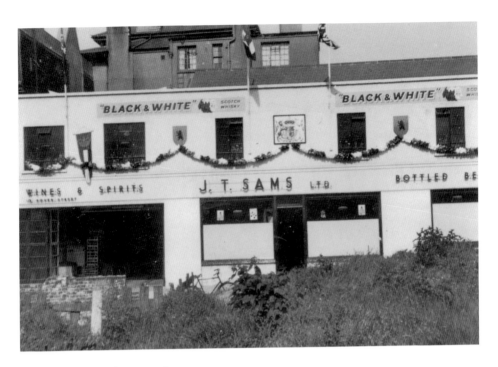

J.T. Sams Ltd., Wine Merchants.

The business of J.T. Sams Wine and Spirit Merchants was established in the 1880s at No. 3 Tontine Street. The company's bottling store as seen here was at 1–3 Dover Street (now Harbour Way). The building has been decorated for the coronation, on 2 June 1953, of Her Majesty Queen Elizabeth II. The premises are now occupied by 'The Party Bar' nightclub and Churchill's pool, snooker and social club.

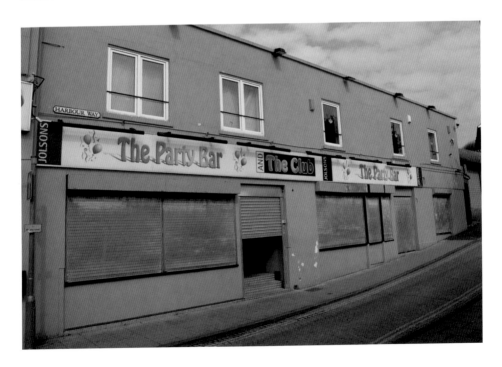

Little Fenchurch Street, looking upwards on 11 May 1923.
The building on the left-hand side is No. 15 Dover Street and is occupied by Charles Russell, cabinetmaker and upholsterer. The view today has changed beyond recognition due to the slum clearances of 1937 and shelling on 9 November 1942. Little Fenchurch Street is now part of St Michael's Street.

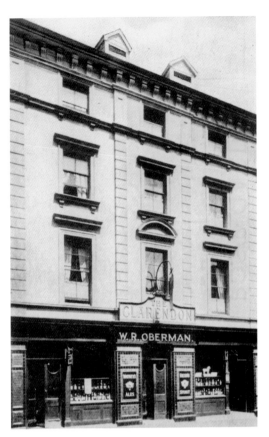

Clarendon Hotel, Tontine Street.
The Clarendon Hotel at No. 8 Tontine Street was next to J.T. Sams, wine and spirit merchants. It opened in 1850 as part of the prestigious development of Tontine Street by the Folkestone Tontine Building Company, in conjunction with the Earl of Radnor and the architect Sydney Smirke. In 1992 the premises were acquired by Harry Hall and by January 1994 it had been incorporated with Jolson's nightclub next door. The nightclub's name has since been changed to 'The Party Bar.'

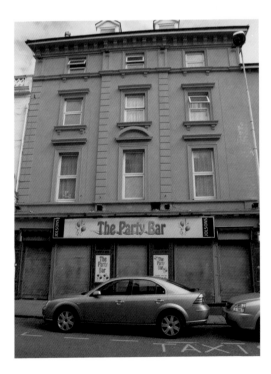

North Street, looking upwards in the 1950s.

The houses on the left-hand side were demolished c.1961. The Lifeboat has been an alehouse since 1861. It was one of the smallest public houses in Folkestone, but in 1956 the brewers acquired the ground floor of an adjoining house (seen in the photograph) which was due to be demolished and they used it to extend the bar. The present-day picture shows that the houses on the left-hand side have been demolished and an access to Dyke Road has been built providing an easier route for the emergency services.

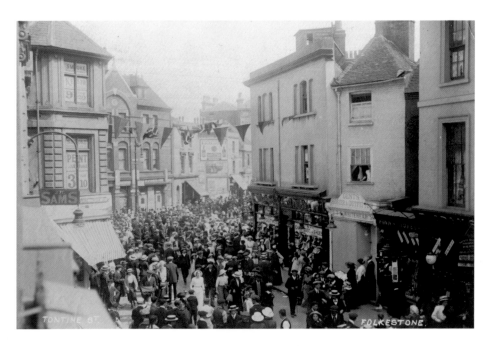

The Lower End of Tontine Street, looking into Harbour Street *c*.1913.

On the left-hand side can be seen the sign of J.T. Sams, wine merchants, while the tall building on the right-hand side is on the corner of the Old High Street. The buildings straight ahead, where the crowds of people are coming from, are in Harbour Street. These buildings were demolished by a parachute mine on 18 November 1940. All the buildings which were destroyed during the Second World War have not been replaced, and most of the area is now taken up with a car park.

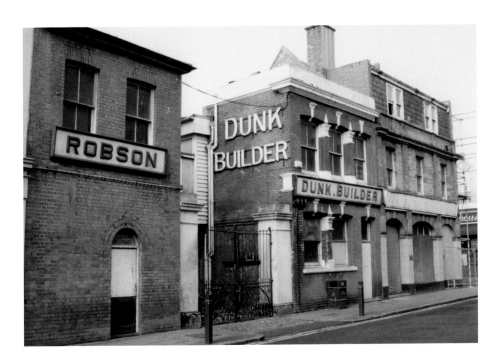

Tontine Street.

These buildings of the old established building firm at No. 47 Tontine Street were demolished in March and April 2007. The state-of-the-art building occupying the site now is a new entertainment venue, the 'Quarterhouse', which opened on 6 March 2009. It is in the heart of Folkestone's Creative Quarter.

Mill Bay.

Looking along the road from the Old High Street towards Dover Road. Harry Webb, seen here with his handcart, was a second-hand furniture dealer who lived and traded at No. 21. The buildings on the right and left-hand sides of the picture were demolished in 1960. Further along the road on the left-hand side can be seen the University Centre part of which was formerly a glass works.

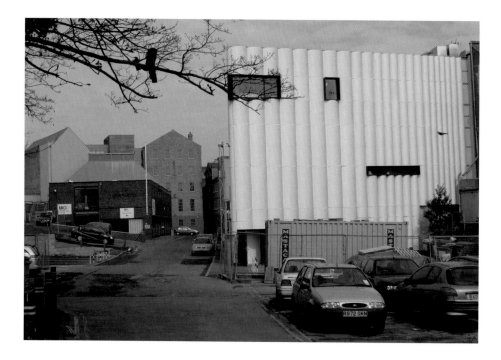

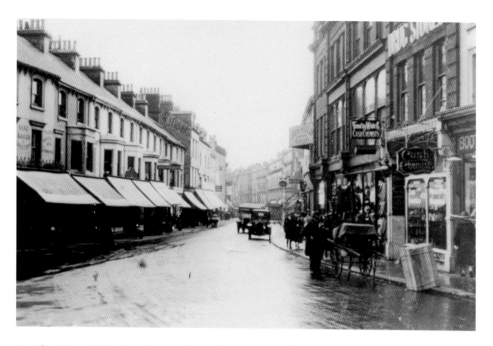

Tontine Street, looking towards the Harbour in the 1920s.

A Folkestone Tontine Building Company was formed with the intention of making a road up the Valley to meet Mill Lane (Dover Road), the Pent stream being confined within a culvert under the new road. The new road began in 1848 and it was intended to provide a modern shopping centre in the Regency style. The town was not ready for this development and only the lower half of the street was built at first. But by the 1890s the top end of Tontine Street was built making it the busiest shopping centre in the town. Today many of the premises are owned by the Creative Foundation including the ones on the right-hand side of the picture.

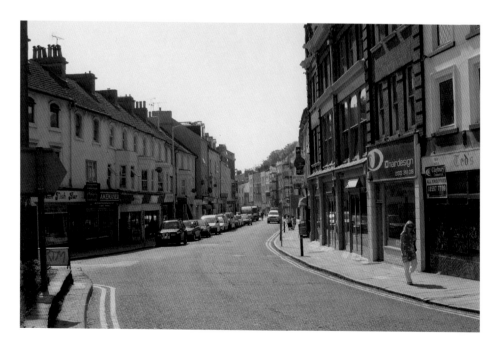

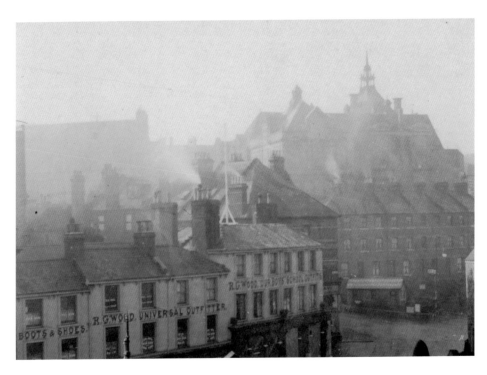

A Bird's-Eye view of the Dover Road end of Tontine Street.

Mr Reginald G. Wood, merchant tailor and universal outfitter occupied Nos. 73-81 Tontine Street. Mr Wood took over the business at these premises from Mr T. Logan *c*.1893. The business continued trading until 1955. Mr Wood was mayor of Folkestone from 1919 to 1922. The premises are now occupied by 'Screen South', owned by the Creative Foundation and are called 'The Wedge.'

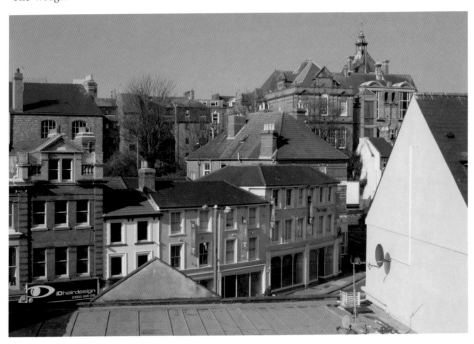

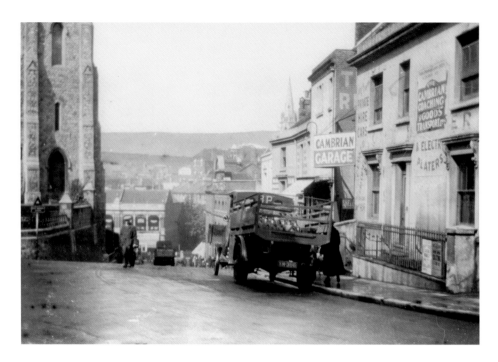

Dover Road, looking down from Grace Hill, on the 10 May 1923.

Among the businesses on the right-hand side are Cambrian's Garage, W. Grinstead (Confectioner), W.F. Bruce (furniture dealer), R. Todd (exchange and mart), G. Kettner (dealer in antiques and books), S.H. Jones (tobacconist), J. Page (confectioner), T. Gosling (greengrocer) and Bridges & Co (carriers and furniture removers). On the left-hand side is the Wesleyan Church. All the shops on the right-hand side were demolished in 1972, and the Wesleyan Methodist Church has been replaced with a complex of sheltered flats called Grace Court.

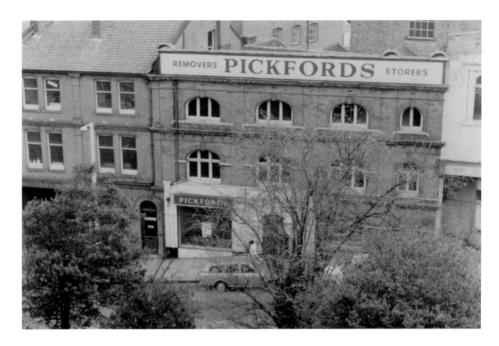

Dover Road.

Pickford's Furniture Depository at Nos. 18 and 20 Dover Road was formerly Bridges & Co. furniture carriers from 1892 to 1937, when the business was taken over by Pickford's. This was the site of the Folkestone Dispensary, a forerunner of the Royal Victoria Hospital. The buildings were demolished in 1972, just after the photograph was taken, exposing the two buildings behind with gable ends. These buildings are now part of the University Centre, Folkestone.

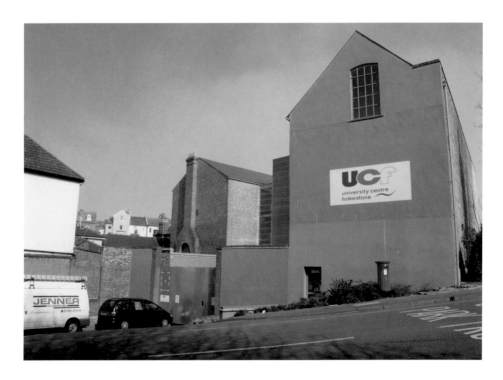

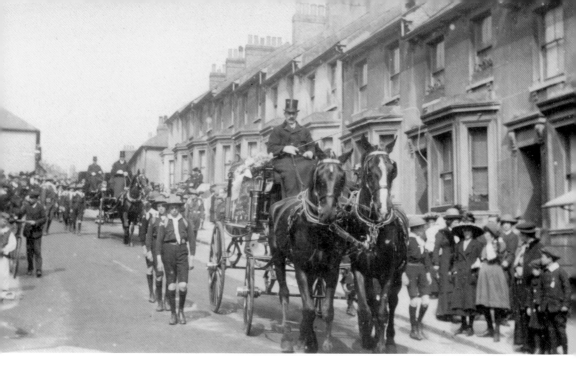

Clarence Street, looking upwards.

A horse-drawn funeral makes its way down Clarence Street. The deceased may have been a member of the boy scouts as there are a number of boys in scout uniforms. Surprisingly, Clarence Street hasn't changed over the years.

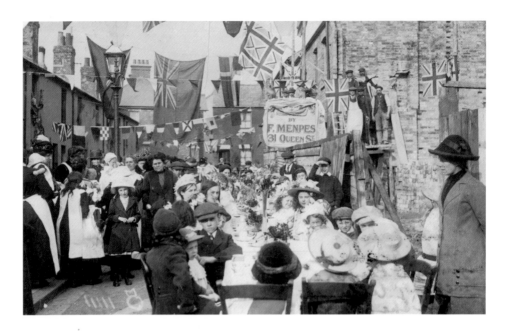

Peter Street.

The bunting is out and the children are having a party to celebrate May Day 1913. It's interesting to note some more houses on the right-hand side are in the process of being built by Mr F. Menpes. In 1962 the terrace of houses on the left-hand side were compulsorily purchased by the Council and demolished. This complex of twenty-six council flats and garages, called Rowen Court, now occupies the site. They were built in 1967–8.

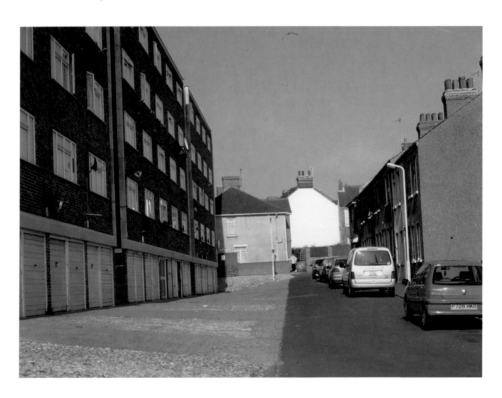

No. 97 Dover Road.

John Hunt, baker and confectioner, was in business at these premises from 1911-13, but it had been a bakery since around 1892. When the photograph was taken Mr R. Watson, a picture framer, occupied half the building. John Strickland took over the whole premises including the bakery in 1929. He opened the sub-post office in 1942, the sub-post office having previously been at No. 101a Dover Road. John retired in 1969 and was succeeded by his son David. In March 2009 David retired and handed the business over to his daughter Kate Richmond, and her husband Giles who is the baker today can be seen in this present day picture.

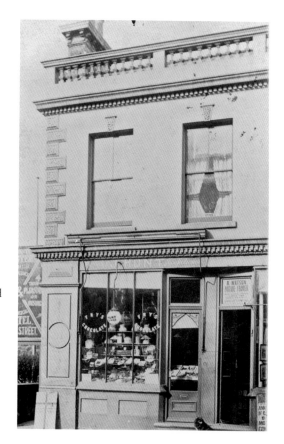

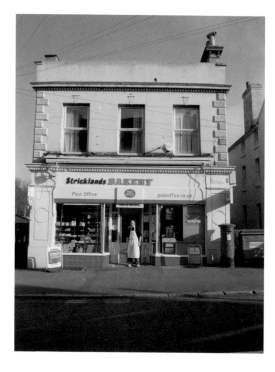

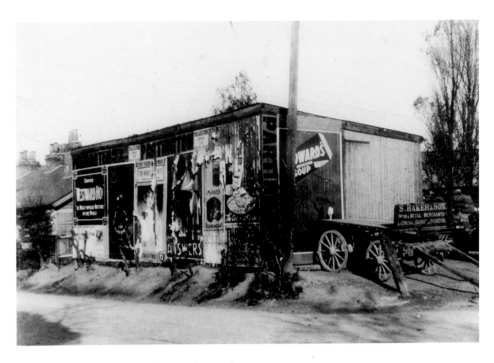

S. Baker & Sons, Iron and Metal Merchants.

The company was established in 1880 by Mr S. Baker, at an old farm just outside the town centre. In the 1890s Mr Baker moved to this building which stood on the corner of Green Lane and Canterbury Road. This site was later occupied by the Crete Way Filling Station and is now Canterbury Close.

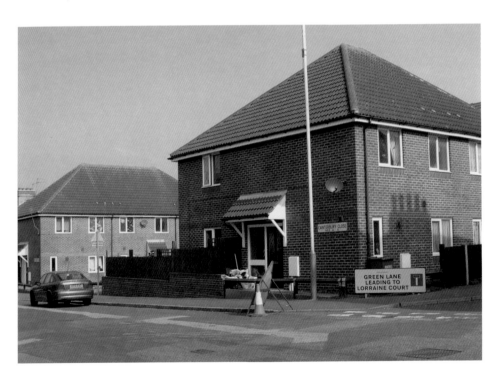

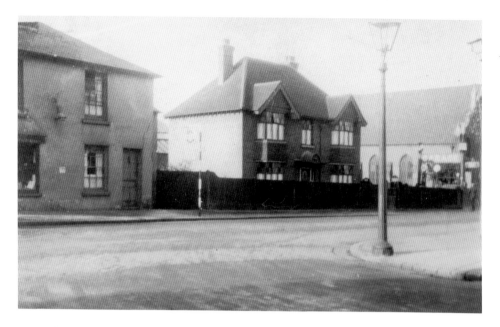

Canterbury Road.

The house on the left-hand side of the picture was occupied by Alfred Elgar when the photograph was taken in 1932. The next building seen here on the corner of Archer Road was occupied by Mr F. Macklin who had petrol pumps in front of the house and a garage at the back in Archer Road. On the opposite corner of Archer Road can be seen the Wesleyan Church. Today, the new Salvation Army building which opened in 2002 stands on the site and there is a town house where the Wesleyan Church once stood.

Downs Road.

Folkestone's 'urban sprawl' was gathering pace when this photograph, looking along Downs Road from Canterbury Road, was taken in 1932. In the 1933 Street Directory there were only two properties listed as being occupied. It's interesting to note the ornate gas lamp and telephone kiosk on the corner. By 1937 the whole of Downs Road had been developed as seen in the present day picture.

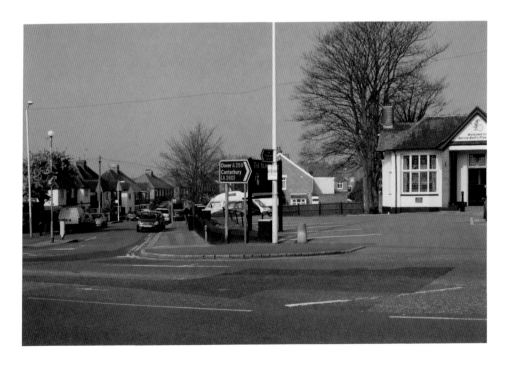

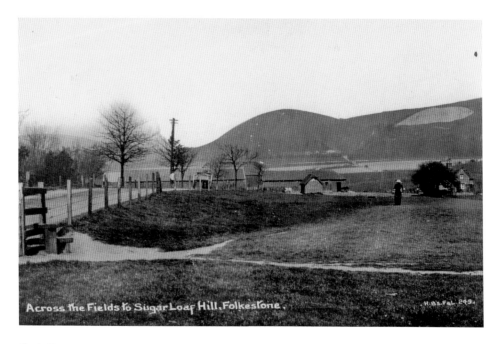

Across the Fields to Sugar Loaf Hill, Folkestone.

Park Farm.

The message on this postcard dated 1916 reads: 'Dear Mabel, This is the sort of country around Folkestone, how would you like to be here? The weather is glorious and I am enjoying myself immensely. The place is covered in soldiers, so perhaps Gertie would like to be here. Love from Kellie.' Few scenes shown in this book have changed as much as Park Farm. Were it not for the hills in the background it would be very difficult to say where the picture was taken.

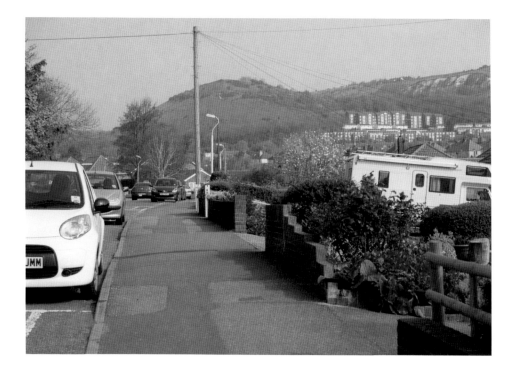

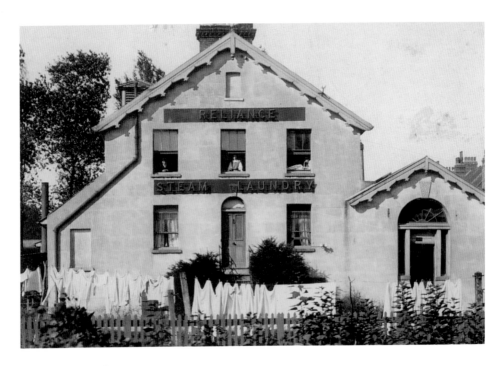

Park Field Road.

In the 1890s laundries started springing up to service the needs of Folkestone's hotels and boarding houses. This one, the Reliance Stream Laundry, was situated in what is now called Park Field Road. It was in business from 1903 to 1921. The present day picture bears no resemblance to the earlier one, and a Kingdom Hall of Jehovah's Witnesses now occupies the site.

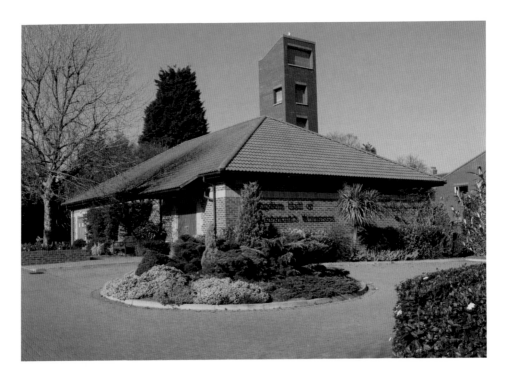

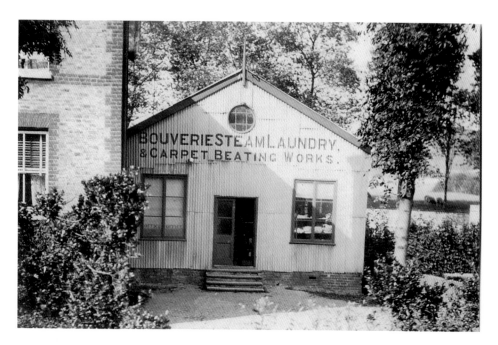

Park Field Road.

Bouverie Stream Laundry run by W. Salter and Son, was also in Park Field Road from 1906 to 1940. On the morning of 26 August, during a German bombing raid, the premises were hit by an H.E. bomb, destroying the building and killing three of the workers. Today the site is occupied by Folkestone Fire Station.

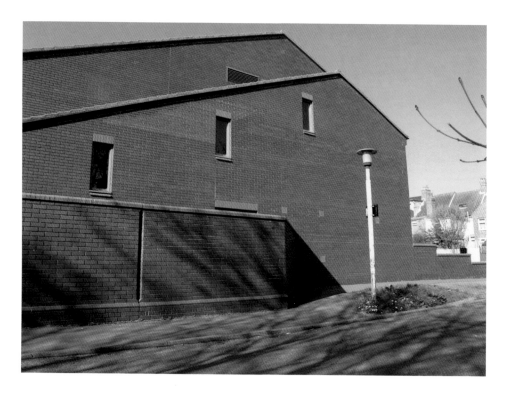

Radnor Park Road.

This view shows the junction of Radnor Park Road and Park Farm Road in September 1949. On the right-hand side can be seen the Fire Station, while the shed in the centre foreground marks the position of the path to Radnor Park. Today this section of Radnor Park Road where the picture was taken from is one-way and there are three lanes of traffic. The right-hand lane leads to Pavilion Road, the middle lane to Park Farm Road and the left-hand lane continues up Radnor Park Road.

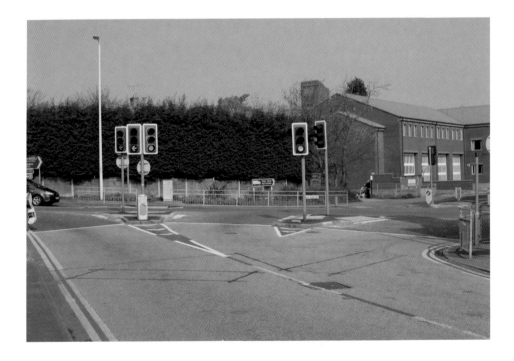

No. 67 Radnor Park Road.
This half weather-boarded cottage
was the home of Albert Clark and
his family when the photograph was
taken in 1919. The family can be
seen standing outside posing for the
camera, they lived here from 1918 to
1931. The old house was demolished
in the 1930s and the present property
was built on the site.

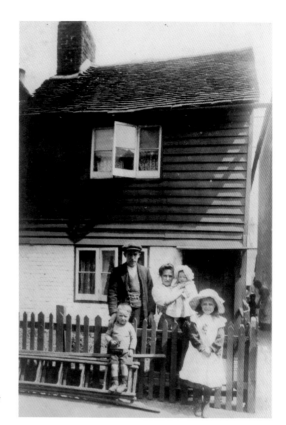

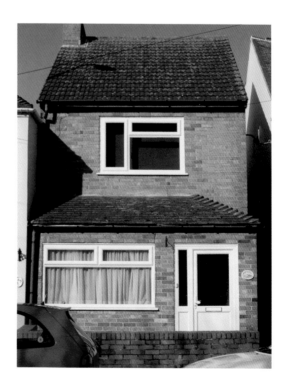

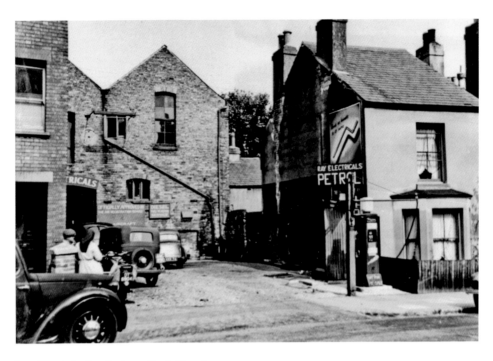

Ray Electricals, Radnor Park Road.
Ray Electricals started trading at these premises Nos 81-83 Radnor Park Road from the 1940s until the early 1980s. The photograph was taken by Lambert Weston in 1949. On the right-hand side of the picture can be seen a petrol pump with an arm which swung out over the vehicle. Currently Auto Electrical Services operate from this building.

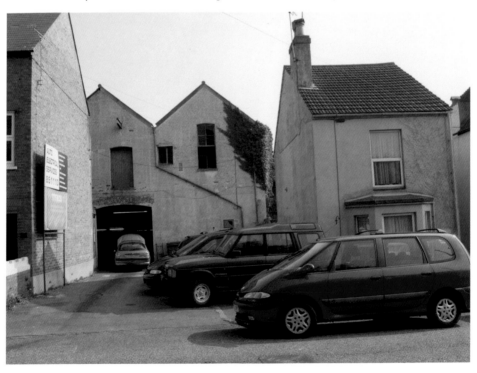

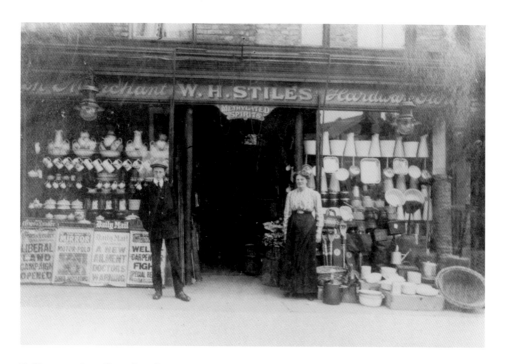

Folkestone's Oil and Colour Store.

William Henry Stiles started trading at these premises No. 34 Black Bull Road (at the corner of Linden Crescent) in 1890. The name changed to Crescent Stores c.1945 when Mr Stiles took in Mr Harding as a partner. The premises are now occupied by the New Century chinese take-away.

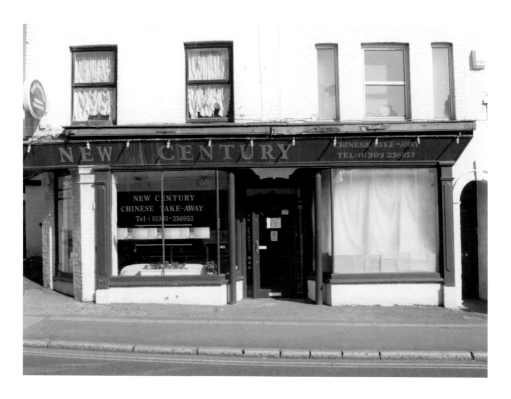

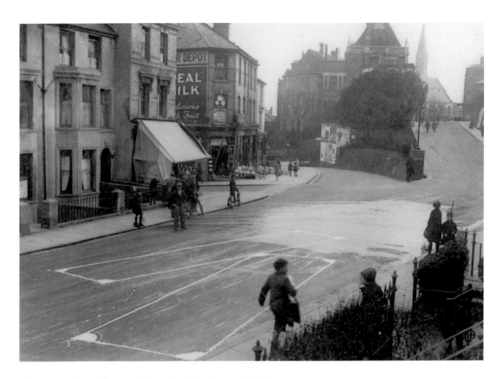

The Junction of Foord Road with Grace Hill, 1930s.

On the left-hand side can be seen the hosiery business of Chas. Tryon, next comes New Street followed by the business of Rye & Sons, oil & colour store. On the right-hand side can be seen the Technical Institute followed by the Wesleyan Methodist church. Present day Foord Road terminates at the junction with New Street, making the remainder of Foord Road to Dover Road (now called Foord Road South) a cul-de-sac.

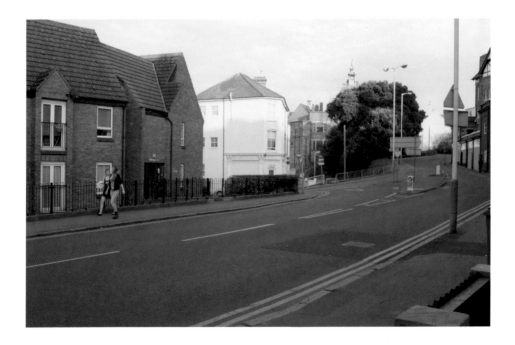

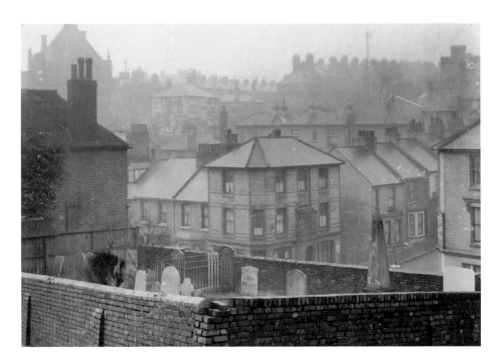

Baptist Burial Ground.

The Old Baptist Burial Ground and New Street from the backs of the houses in Mount Pleasant Road. The graveyard which stands high above Bradstone Road has a frontage of fifty-five feet, and it covers roughly one third of an acre. The date of the first burial that can be verified is the burial of Bennett Stace in 1747, aged 29. The burials stopped on 1 September 1855, after which date they took place at Cheriton Road. The building on the corner of New Street was occupied by one Reginald Percy Hawkins, boot repairer, from 1912 to c.1952. The property was demolished in 1973 and the site to this day is still an open space.

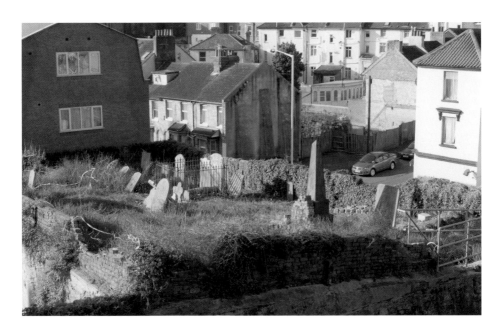

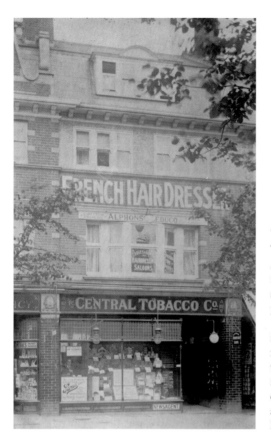

Tobacconist.
The Central Tobacco Company, and Alphonse Educq hairdressers on the first floor were at 102 Cheriton Road. The shop had sold tobacco from 1908, but the photograph was taken sometime between 1912 and 1922. Between 1974 and 1998 it was a newsagents. It's interesting to note the splendid gas lamps, but would they survive the activities of late night revellers today? The premises are now an extension to the Co-op Welcome store at 100 Cheriton Road on the corner of Brockman Road.

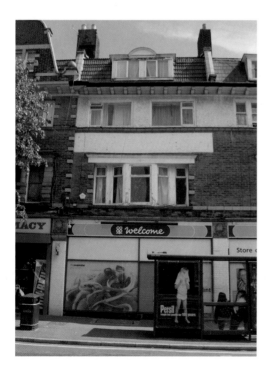

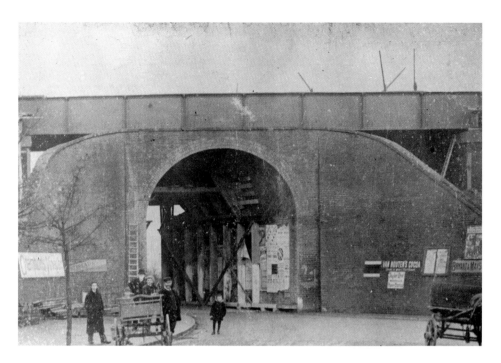

Central Railway Arch.

The needs of road vehicles were gradually having to be addressed as some of the railway bridges were much too narrow. The first to be replaced in Folkestone was Cheriton Arch, near the Central Station, which was replaced in 1890 with a steel girder span bridge as seen in the picture. The steel railway bridge in today's picture was refurbished in 2002.

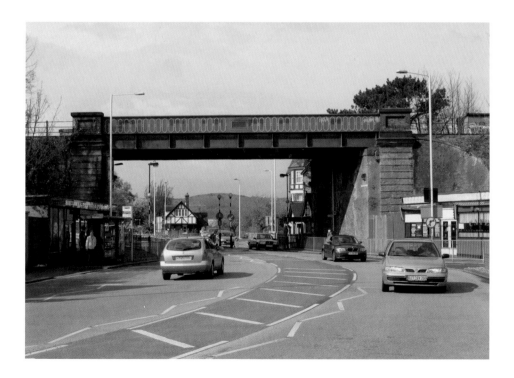

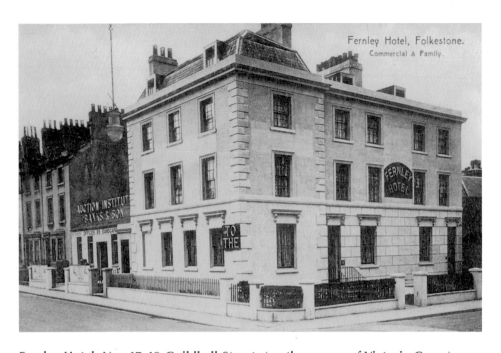

Fernley Hotel, Nos 47-49 Guildhall Street, (on the corner of Victoria Grove).

Rockhill House School for young ladies started at 15 Victoria Grove in 1856. They took additional premises at Nos. 47-49 Guildhall Street in the early 1870s. In 1906 the premises were transformed into the Hotel Fernley. Finally, in 1949, the hotel was converted into flats, as can be seen in the present day picture.

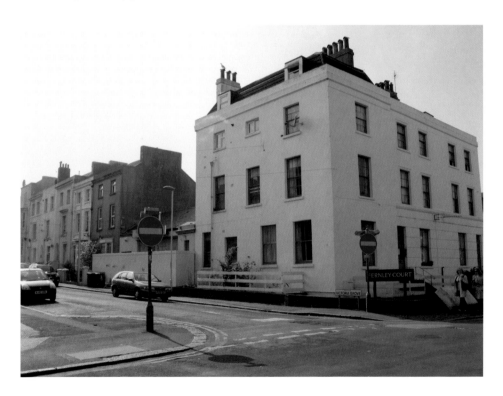

Copthall Gardens, looking downwards, in the 1930s.

The Great and Little Copt Hall were fields that, in 1698, belonged to the King's Arms Farm, and whose names have survived to this day in the street name, 'Copthall'. The differences between the two pictures are relatively minor apart from the road sweeper's barrow, the hand cart and car. Copthall Gardens came out in Shellons Street until the northern distribution road was built in 1973. Since then it has been a cul-de-sac.

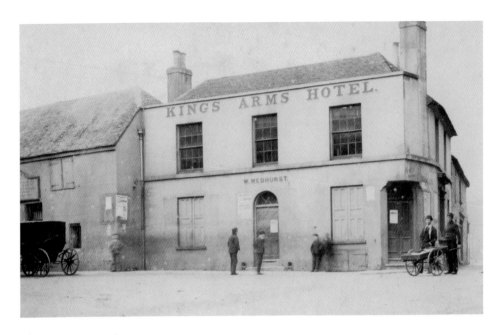

Kings Arms Hotel.

The photograph was taken by Walter Blackall of No. 9 Church Street, Folkestone. The doorway on the corner was inserted after the building was constructed. Demolition commenced on 20 June 1882 of both the Kings Arms and the adjoining Livery Stables of Michael Pierrepont Valyer. The opportunity was taken at the time to widen Guildhall Street. The Queens Hotel was built on part of the site, opening on 18 January 1885. Just seventy-eight years later, in 1963, the Queens Hotel was demolished, and the site is now occupied by Queens House.

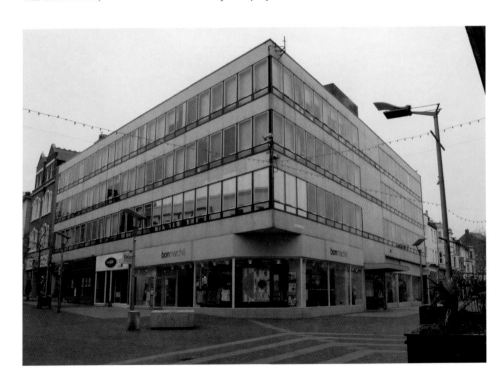

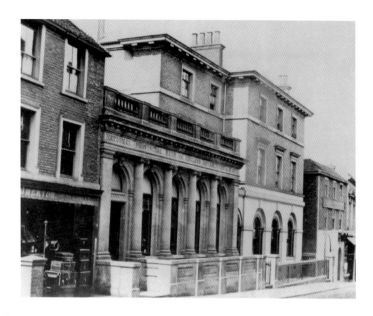

Sandgate Road, in the 1870s.

The shop on the left-hand side was owned by a Mr Munckton, who was an army hunting and harness maker, and the premises are now occupied by Three Cooks Bakery. Next door is the National Provincial Bank which opened in 1833. The premises were taken over by Woolworths in the 1920s. Part of Woolworths was taken over by Ottakars in 1995, which was taken over again by Waterstones in 2008. Woolworths went into liquidation in December 2008, and closed all their branches. Forty-three members of staff lost their jobs at the Folkestone Branch.

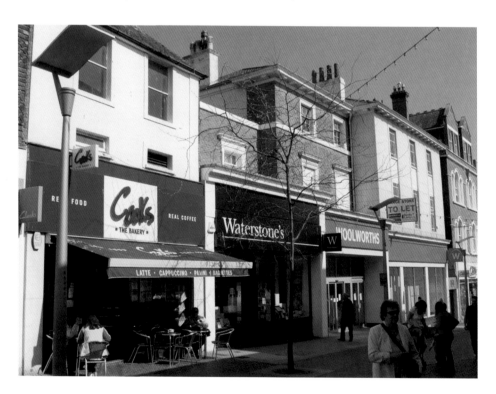

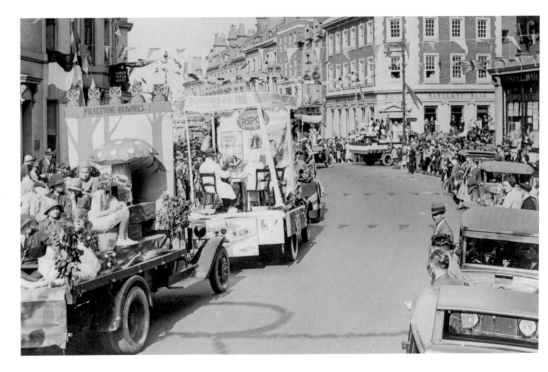

Jubilee Celebrations.

A procession in Sandgate Road to celebrate the Jubilee of King George V and Queen Mary on the 6 May 1935. The float nearest the camera is that of the Folkestone Brownies, and the one next to it belongs to the RSPCA. Further along the road, floats can be seen turning into West Terrace by Barclays Bank. The present day view hasn't changed much apart from the pedestrianised lower end of Sandgate Road and the traffic lights.

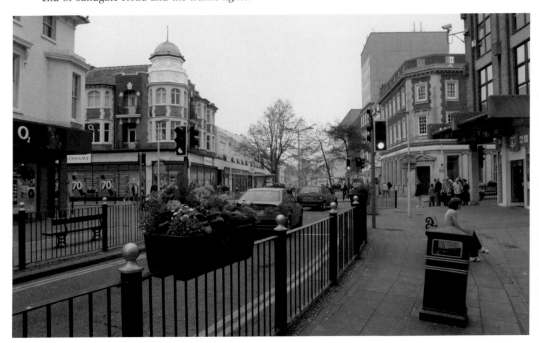

Post Office.

An early Royal Mail vehicle stands outside the General Post Office in Sandgate Road, circa 1910. This Grade II listed building was built around 1880 and incorporates a royal coat of arms on the front gable. The post office moved to new premises in Bouverie Place in 1937. Note the man on the top of the vehicle possibly unloading mail bags. The vehicle has solid tyres and carbide headlamps. Today the post office building is occupied by Kentucky Fried Chicken.

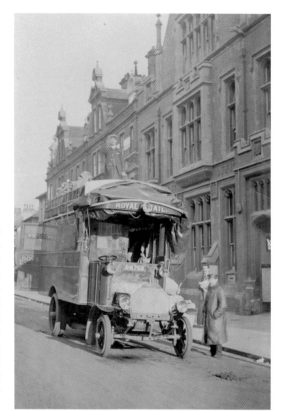

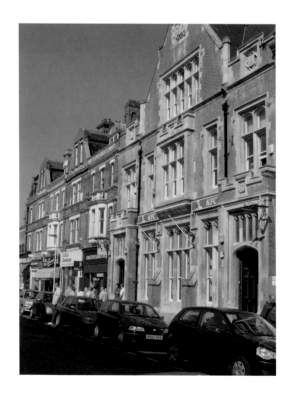

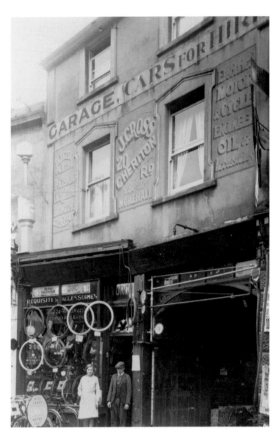

Cheriton Road.
Mr J. Cross of the Central Garage was based at the motor and cycle depot at No. 20 Cheriton Road from 1922 to 1932. Mr Cross also sold petrol from these premises – the sign on the right-hand of the garage door proclaims 'High Grade Dominion Motor Spirit 1/1 per Gallon.' The business was taken over by Cecil S. Samuels in 1933 and is now run by Alford Bros.

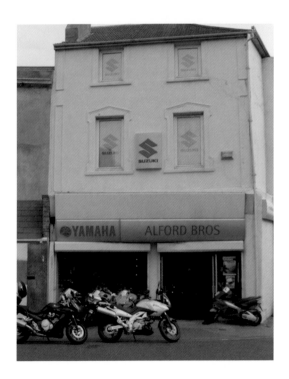

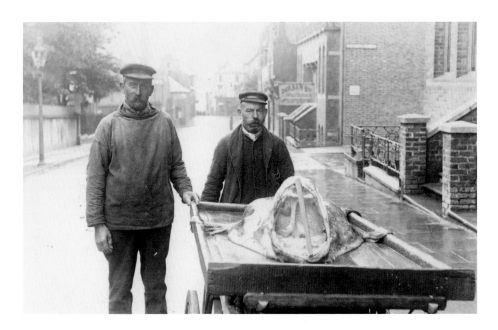

Bouverie Road East.

These two enterprising fishermen who were known by the names of 'Mickey and Messer' have caught an angler fish off Folkestone. They took their barrow round the town and charged a penny to view the rarely-seen spectacle. What a transformation there has been in the modern view! The only building standing today is the one in the far distance at Guildhall Street.

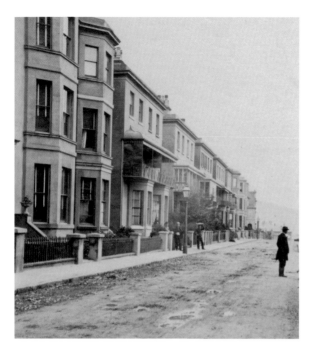

Bouverie Square, c.1870.
All the buildings on the left-hand side were demolished in 1973 to make way for the Northern Distribution Road. It's interesting to note that the road has not been surfaced with tarmac. Today the road is called Middleburg Square. On the right-hand side can be seen the new shopping centre which opened in November 2007, while on the left are the offices of Saga followed by a multi-storey car park.

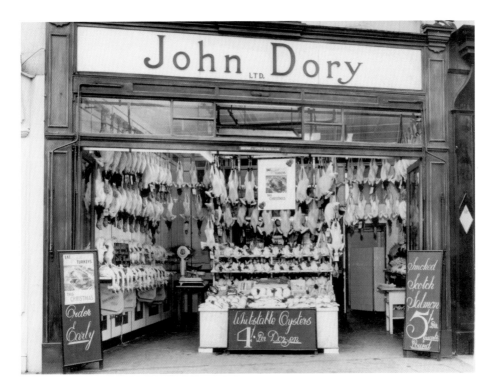

Cheriton Place.

John Dory Ltd, fishmonger, poulterer and game dealer at No. 21 Cheriton Place. The picture shows John Dory's fine display of poultry and fish for Christmas 1955. John Dory traded at these premises from 1929 to c.1975. The shop was then taken over by a greengrocers and fruiterers, trading as West End Fruiterers.

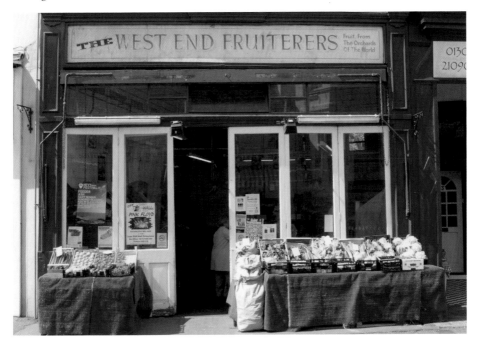

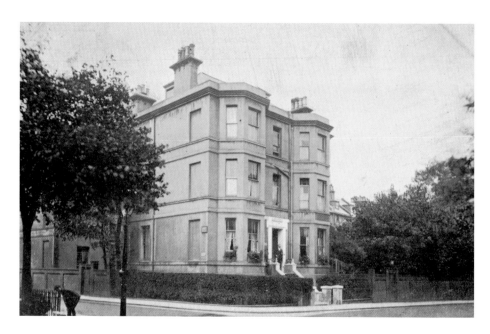

Albion House, 1912.

This Boarding House is at No. 24 Cheriton Place on the corner of Bouverie Square. Today the property is in multi-occupation with Celia's Hair Fashions, Europa Property Services and a Chiropractic Clinic run by Richard C.D. Edwards D.C. It's interesting to note in the earlier picture that the three single storey shops on the right-hand side of the present day picture haven't been built!

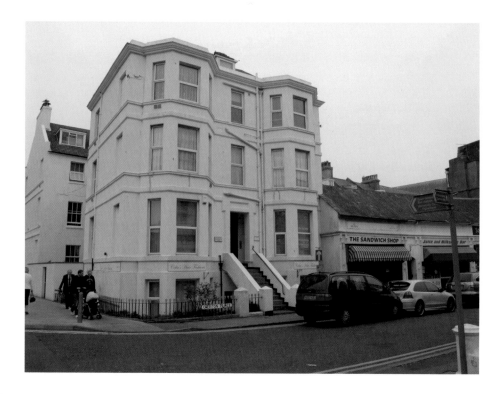

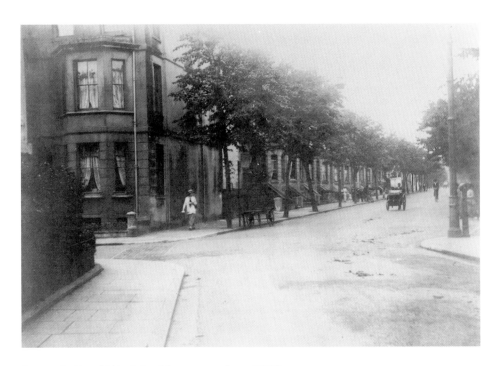

Bouverie Road West, looking upwards, c.1910.
Most of the properties on the left-hand side of the picture were demolished in the early 1980s to make way for Sainsbury's supermarket who were re-locating from West Terrace. The earlier peaceful scene with just two handcarts has given way to a street cluttered with cars!

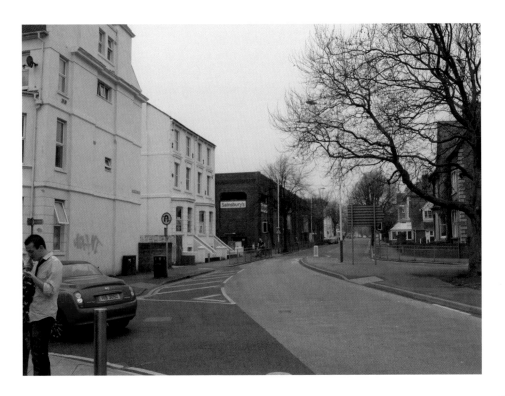

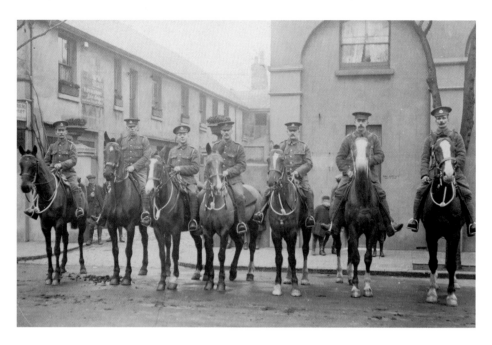

The right-hand side of Christ Church Road.

John Bridger came from Dover in 1901 to start business as a fly proprietor at these premises, No. 9 Christ Church Road. He remained in business until the mid-1920s after which a taxi business was established. The mews makes a fine backdrop for these mounted soldiers pictured sometime during the First World War. Today the site is occupied by five town houses.

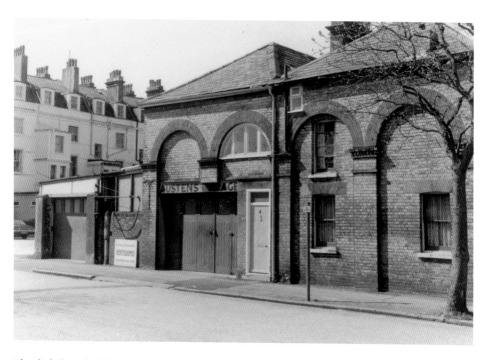

The left-hand side of Christ Church Road.

William Austin opened his garage at No. 4 Christ Church Road in about 1918 and continued to trade there until 1973. It's interesting to note the old petrol pump with an arm which swung out over the vehicle. I doubt whether health and safety regulations would allow the use of this type of pump today! The buildings on the left-hand side of the picture are the backs of the properties in Bouverie Road West. The premises are now occupied by Griffin Vehicle Services.

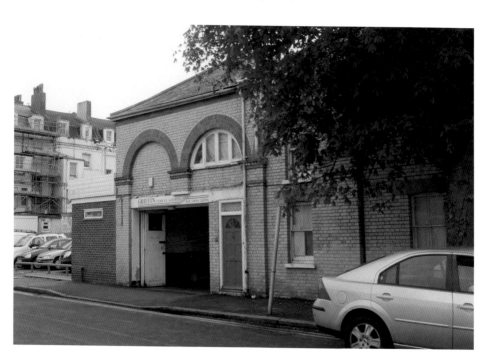

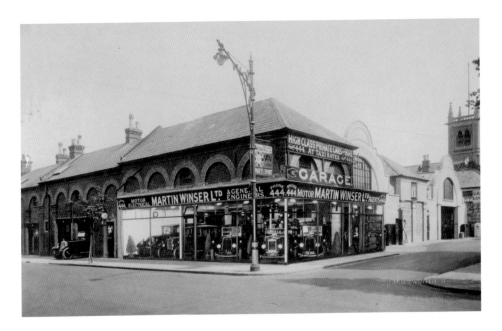

Martin Winser Ltd.

Clifton Garage, motor engineers, coachbuilders and car rental at Christ Church Road on the corner of Bouverie Road West, occupied these premises from 1912 to c.1959. The building has since been transformed from a garage into a funeral parlour run by W.J. Farrier & Sons Ltd., Independent Family Funeral Directors. It's interesting to note that one can see the tower of Christ Church in Sandgate Road.

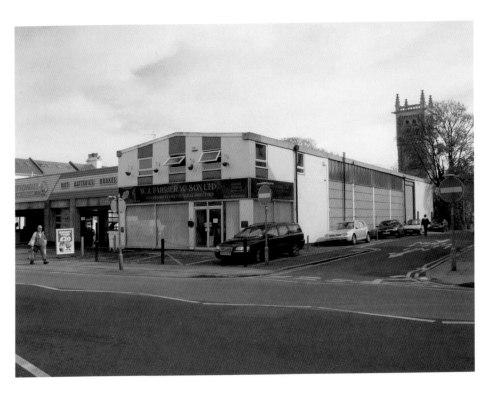

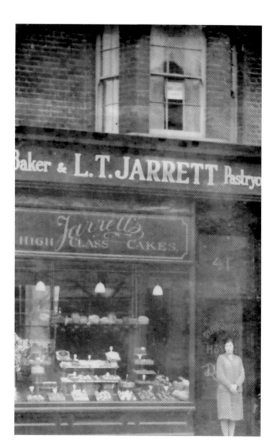

41 Bouverie Road West.

Mr L.T. Jarrett, baker and pastry cook
started at No. 229 Cheriton Road
calling his business St. George's Bakery.
He was at those premises from 1925 to
1928 after which he moved to No. 41
Bouverie Road West where he stayed
until 1932. He also had another bakery
at No. 60 High Street during the same
time as he was at Bouverie Road West.
In 1933 he moved next door to No. 39
Bouverie Road West. At the present time
No. 41 Bouverie Road West is vacant.

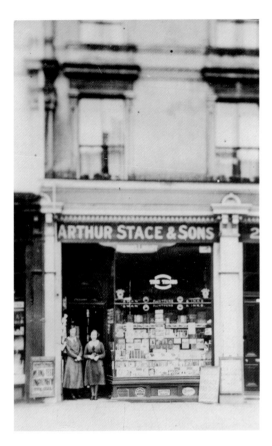

Bouverie Road West.
Arthur Stace & Sons, started their stationary business in 1926 at No. 22 Bouverie Road West and continued there until sometime between 1940 and 1947. The lady on the left-hand side is Mrs Radcliffe, and the photograph was taken in October 1932. The shop continued as a stationers' for many years but is now Conchitas Mexican Canteen café.

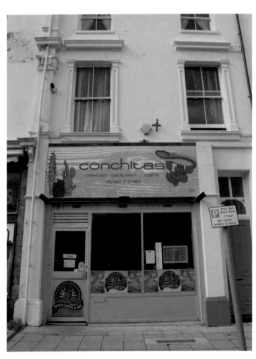

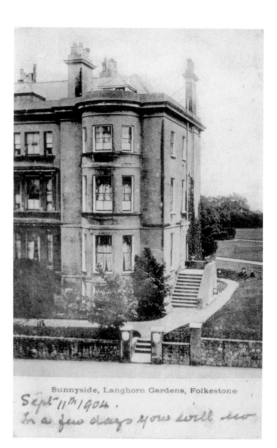

Sandgate Road.

Sunnyside Private Hotel, *c.*1904. The property is one in a terrace of three which stood in Langhorne Gardens and fronted Sandgate Road. The three properties were destroyed by enemy action during the Second World War. Today the site is occupied by Waldorf Apartments, a complex of forty spacious apartments and penthouses, built in 2001 by Gillcrest Homes.

Sunnyside, Langhorn Gardens, Folkestone

Sept 11th 1904.
In a few days you will see

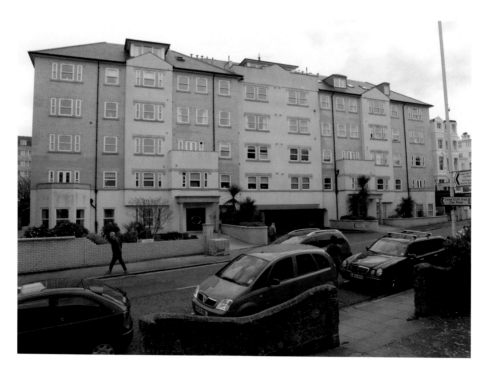

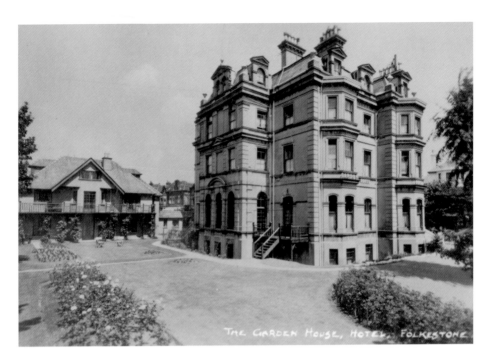

The Garden House, Hotel, Folkestone

Garden House Hotel, 142 Sandgate Road.

The hotel was gutted by fire on the 3 July 1999. The building was so badly damaged it was subsequently demolished. Garden House Court, a complex of one and two bedroom retirement apartments, built by McCarthy & Stone, now stands on the site.

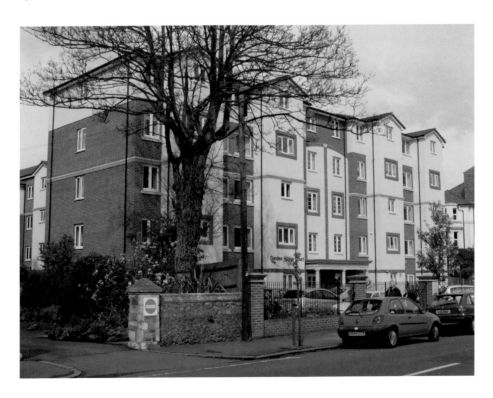

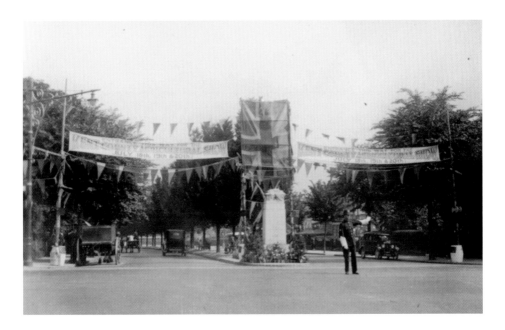

Kent County Agricultural Show.

The picture shows the entrance to Cherry Garden Avenue from Cheriton Road. Two banners spanning the two-lane carriage way are advertising the Kent County Agricultural Show, which is being held on 18-20 July 1929. It's interesting to note the policeman on traffic duty and the Machine Gun War Memorial which has been moved to Cheriton Road Cemetery. The view as seen today shows the introduction of traffic lights and more road lanes.

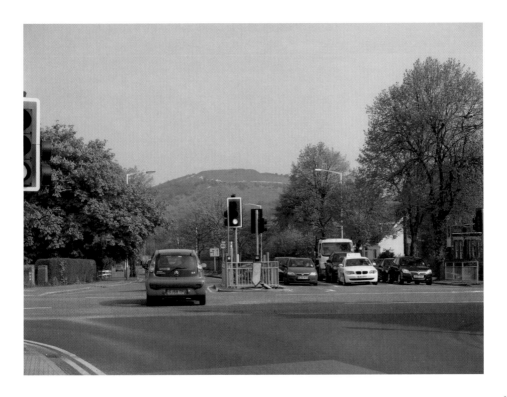

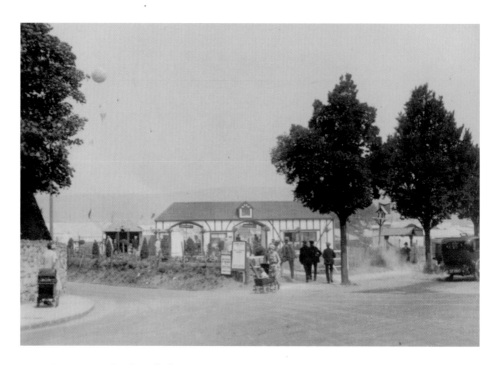

Kent County Agricultural Show.

The picture shows the main entrance in Cherry Garden Avenue at the junction of Cherry Garden Lane. This show is the seventh Kent County Agricultural Show to be held, the first one being in 1922. It's interesting to note that some of the exhibits can be seen near the entrance. Today's picture shows quite a contrast to the earlier one, as the area is now covered with a housing estate.

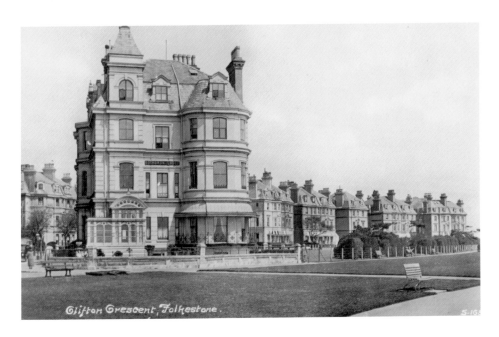

Clifton Crescent, Folkestone.

Clifton Crescent.

Sothoron Lodge at No. 33 Clifton Crescent was run by Miss Philip as a boarding house from 1905 until November 1916, when all of Clifton Crescent was acquired by the military and opened as No. 3 rest camp early in 1917. The rest camps were set up to accommodate troops coming home from the front during the First World War. The building was demolished in February 1961 and replaced with this modern block of flats, spoiling this Victorian Crescent.

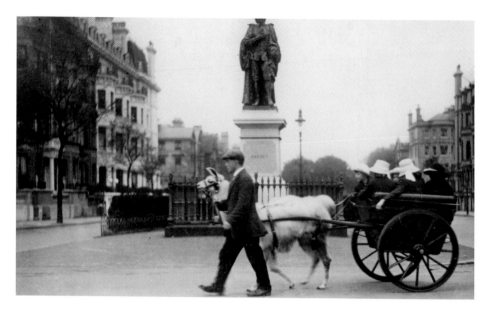

The Harvey Statue, unveiled in 1881.

The statue of William Harvey, the gentleman doctor who discovered the circulation of the blood, stands between Clifton Gardens and Langhorne Gardens, making a fine backdrop for this llama cart. Charlie Rodwell (junior) is seen here giving rides with the llama 'Tiny.' The present day view hasn't changed much except for the absence of the llama cart, but I don't expect modern regulations would allow them to operate nowadays!

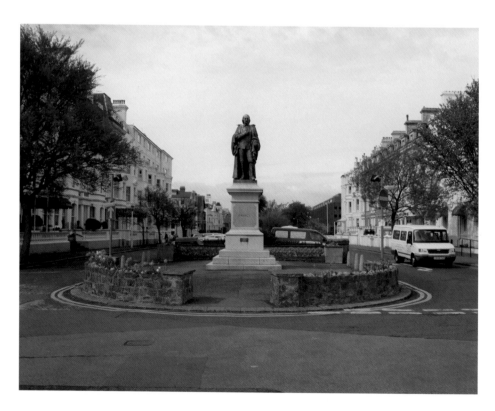

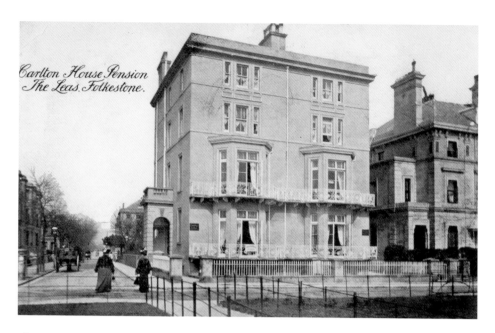

The Leas.

The Carlton House Pension stands on the corner of Shakespeare Terrace at Nos 18 and 19, The Leas. It started as a lodging house in Victorian times. The postcard, dated 4 July 1907, shows a fence around grass between the road and promenade. Today the Carlton has been upgraded to a Hotel and is one of a very few hotels that has survived on the Leas.

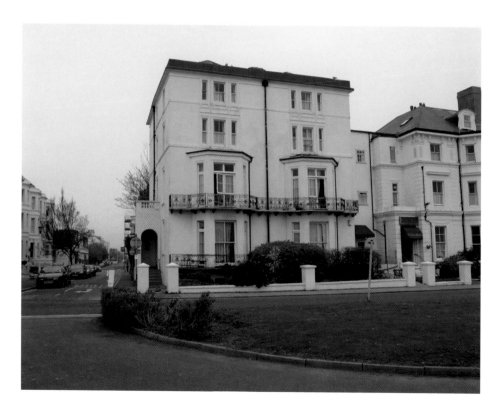

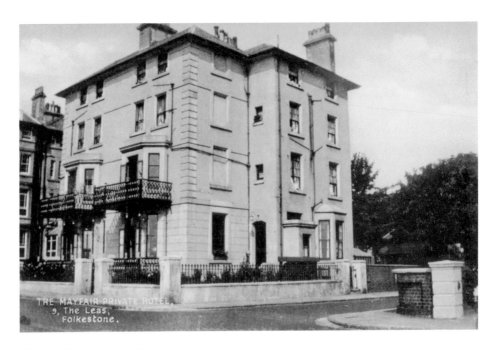

The Mayfair Private Hotel.

This hotel stood on the corner of Cheriton Place at Nos 9 and 10 The Leas. It was demolished along with Moors Hotel and has been replaced with this complex of flats and maisonettes called Whitecliffs. The development started in 1970 with Gerald Glover, owner of the Metropole, at the helm. Thirty-eight flats and maisonettes with underground parking were built on the site by the local builder Jenner & Son Ltd, at a cost of £350,000.

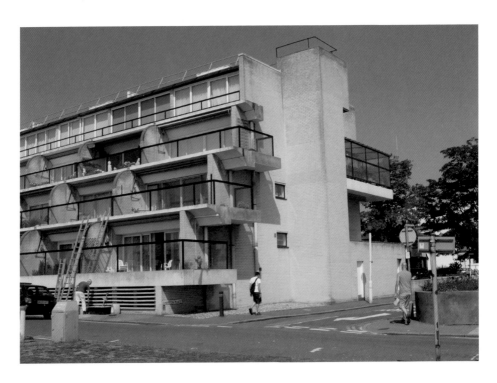

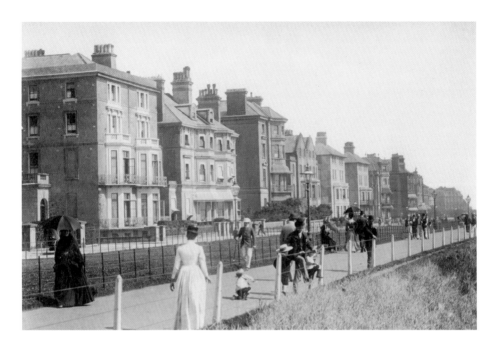

The Leas, looking east, July 1894.

This area is known as the Leas (the original spelling was Lees), a Kentish dialect word meaning a common or open space of pasture. It began to be developed as an exclusive 1½ mile promenade, and select hotels and residences were erected in the 1870s. All the people in the photograph are well covered and some ladies have their parasols up, for suntans were frowned upon in those days. Quite a transformation has taken place in the present day picture, as all the hotels have been demolished to make way for blocks of flats.

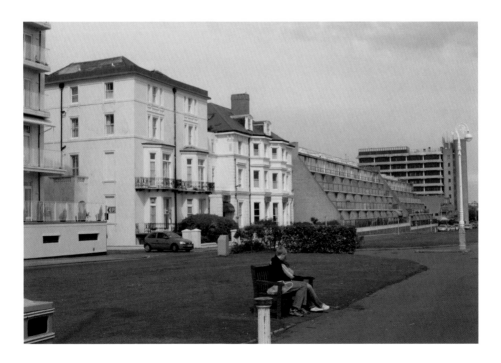

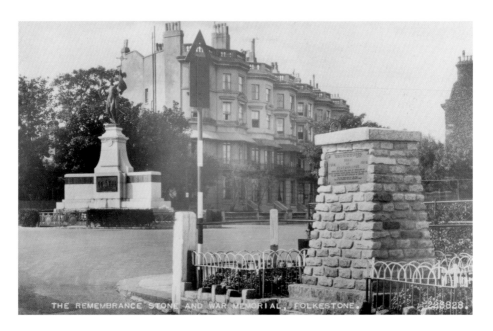

THE REMEMBRANCE STONE AND WAR MEMORIAL, FOLKESTONE.

The Remembrance Stone and War Memorial.

The town's military dead from the First World War were honoured with this war memorial designed by F.V. Blundstone which was unveiled on Saturday 2 December 1922. It is sited at the top of the Slope Road to the harbour, which was renamed the Road of Remembrance after the war in honour of the many troops who went up and down it on their way to and from the front line. The Cairn Memorial (right of picture) dating from 1927 was also erected with the inscription: 'During the Great War, tens of thousands of British Soldiers passed along the road on their way to and from the battlefields of Europe.' The buildings in West Terrace were demolished in the late 1980s and an arcade of shops were built on the site. Sainsbury's opened in October 1970 in the premises which is now occupied by McDonalds.

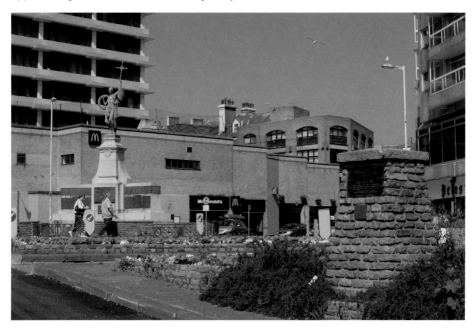

HARVEY MEMORIAL.

CONTRIBUTIONS
TOWARDS THE
MEMORIAL WINDOW
TO BE PLACED IN THE

IN MEMORY OF DR. WILLIAM HARVEY, DISCOVERER OF THE CIRCULATION OF THE BLOOD. BORN AT FOLKESTONE, A.D. 1578.

PARISH CHURCH OF FOLKESTONE.

Collector *M. Woodward*

Harvey Memorial Window.

The Vicar of the Parish Church, Matthew Woodward, raised money to build a Memorial Window in the west wall of the church. It was to be in memory of Dr. William Harvey, discoverer of the circulation of the blood who was born at Folkestone in 1578. This rare card with Matthew Woodward's signature at the bottom has the names and donations of some of the subscribers on the back. Work began in constructing the window in October 1872, and it was completed in 1874. The churchyard today has more trees obscuring the view of the Harvey Window, so the current photograph is not taken from the same spot.

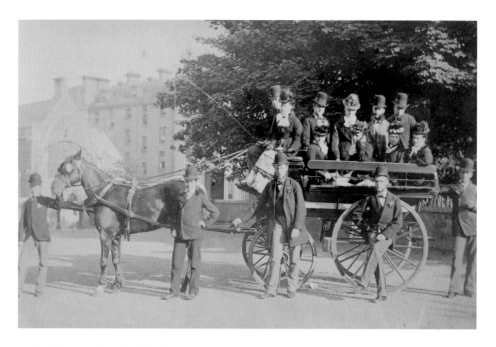

A Wedding at the Parish Church.

The wedding of John Henry George Brett and Mary Ann Garland took place at the parish church in the 1880s. The wedding group are seen here posing for the camera at the end of West Cliff Gardens, while over the horse's head can be seen the parish church. Mr Steven Brett, father of John, is the gentleman sitting on the wheel hub. John Brett had a tailoring business in Rendezvous Street, (see picture on page 83). The present day picture is much the same as the earlier one except for the absence of the wedding and the overgrown state of the churchyard.

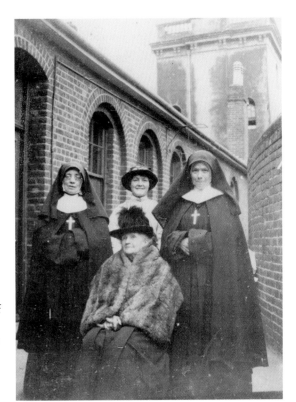

The Bayle.

In 1864-65 Matthew Woodward, vicar of the Parish Church, introduced nuns to the town, some of whom came to live at St Eanswythe Mission House on the Bayle. In 1893 the sister in charge was Sister Edith. The picture shows a group of nuns outside the Mission House. Bayle Court now occupies the site.

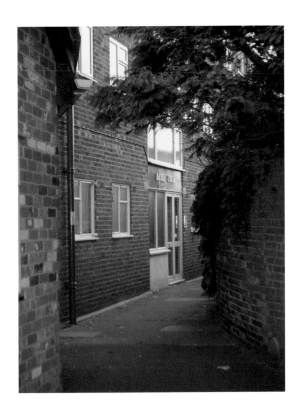

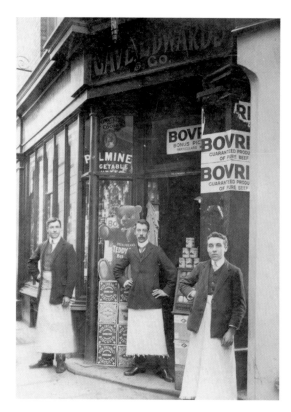

George Lane.
One of the many businesses which came and went relatively quickly was the grocery business of Messrs Cave, Edwards and Co., whose shop here at No. 3 George Lane, just off Rendezvous Street, was in business from 1908 to 1911. Hillside Restaurant currently occupies Nos 3 and 5 George Lane.

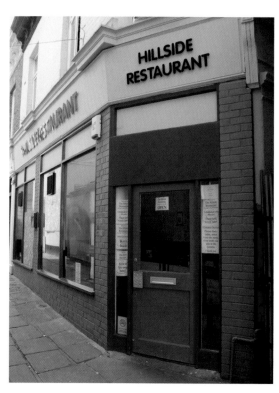

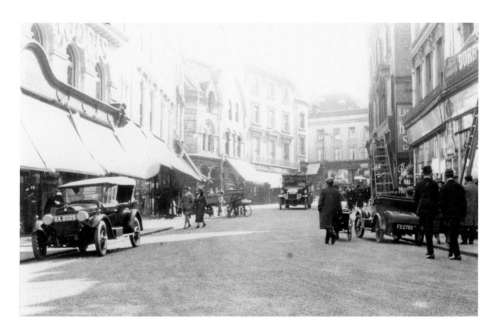

Rendezvous Street, looking upwards.

A busy scene in Rendezvous Street with people going about their business on 14 May 1923. On the extreme left can be seen the business of Plummer Roddis, Drapers, Silk Merchants, Milliners, Costumiers & Complete House Furnishers. On the right is Bobby & Co. Ltd, drapers and high-grade fashion experts. Bobby's moved to purpose-built premises in Sandgate Road on 6 March 1931, (now Debenhams). Plummer Roddis closed in 1972, and their premises were demolished in 1984. The Oriental Buffet, Keith Graham Hairdressing, and a complex of flats now occupy the site.

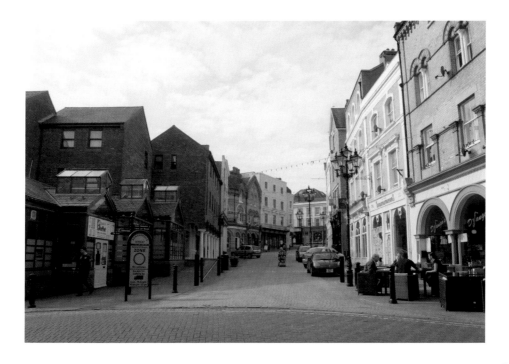

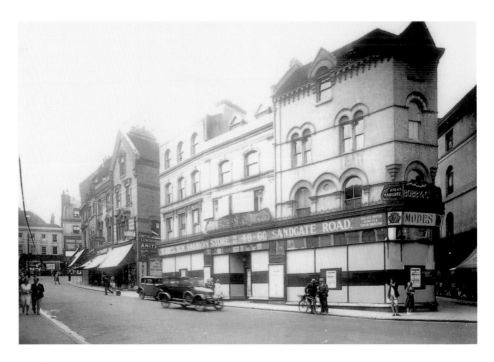

Bobby's Department Store.

Messrs Bobby & Co Ltd., took over the business of C.J. Saunders on the 30 April 1906 at Nos 13 to 17 Rendezvous Street which was known at the time as Bouverie House. The premises are now split into three separate shops, the corner one is Django's Café followed by an empty shop then a Boutique.

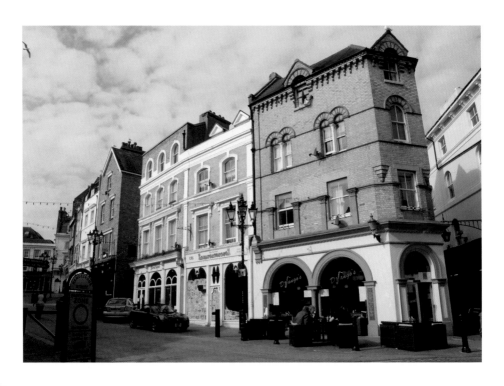

Rendezvous Street.

John Henry George Brett, who was born at Mersham in 1817, started his tailoring business at No. 32 Rendezvous Street c.1883. He can be seen standing in the doorway while his children are looking out the upstairs window. The business took the name of L.A. Brett from 1906 to 1937. The premises are now occupied by the Sweet Rendezvous Café.

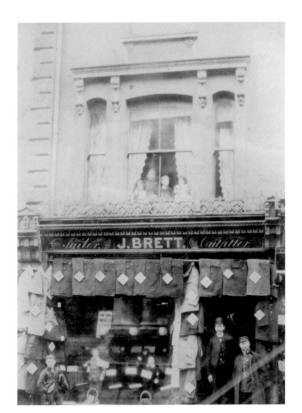

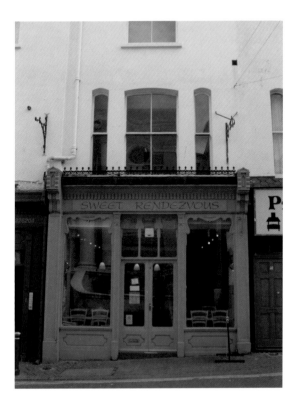

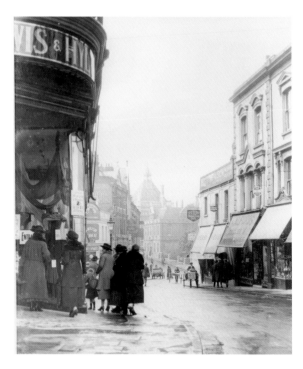

Rendezvous Street, looking down towards Grace Hill in 1923.
On the left-hand side are the drapers, tailors, costumiers, milliners & gentlemen's outfitters shop Lewis & Hyland, followed by the Prince Albert Hotel. While on the right-hand side we have L.A. Brett, hosier, tailor & outfitter; Halford's Cycle Co.; and Vye & Sons, provision merchants & grocers. In the far distance can be seen the Public Library and Technical Institute. Present-day Rendezvous Street doesn't have so many retail shops as in years gone by.

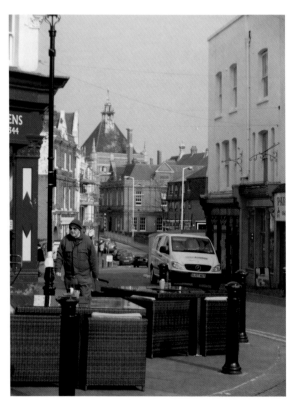

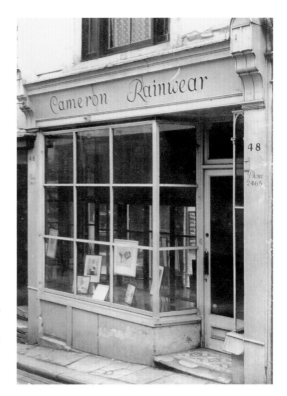

The Old High Street.
Cameron Rainwear traded here at No. 48 High Street between 1940-47 after which it moved to No. 30 Rendezvous Street. The shop is now a masonry business called Quay Stone and is in the Creative Quarter.

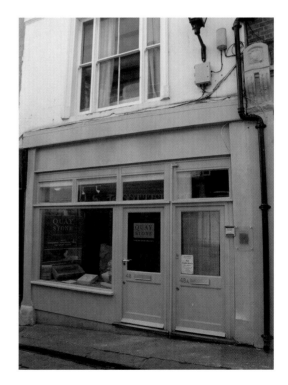

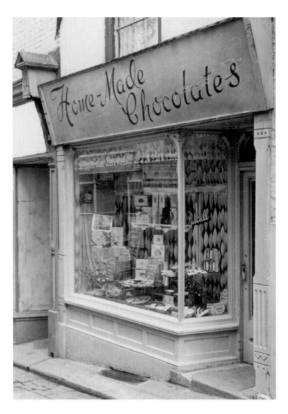

The Old High Street.
Miss M. Newall, confectioner, traded at this shop No. 56 High Street from the mid-1940s until the mid-1950s. These premises, along with No. 58, are now occupied by the Creative Quarter's Information Centre. It's interesting to note a new homemade chocolate shop has opened further up the street in 2008.

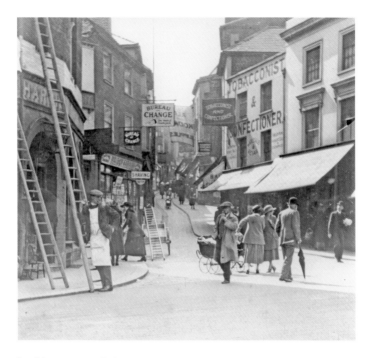

The Old High Street, looking upwards in 1923.

At about this period a number of well known shops traded here such as Marks and Spencer's Penny Bazaar, International Stores, Home and Colonial, Lipton's and Boots. The days when these stores traded in the street, though, have long since gone. Currently, as the properties come on the market, the Creative Foundation is buying them to refurbish or in some cases to re-build and let.

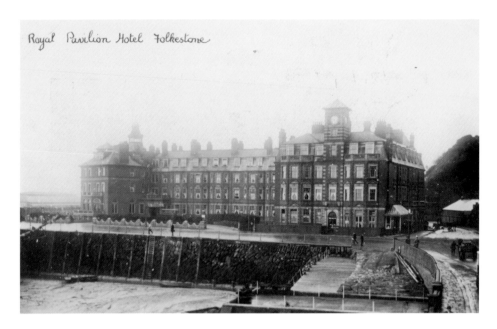

Royal Pavilion Hotel Folkestone

The Inner Harbour.

The Royal Pavilion Hotel makes a fine backdrop for this view of the Inner Harbour. The bow of a sailing ship can be seen on the left-hand side, while the brick structure in the foreground is a sluice gate, built to control the flow of water from the Pent Stream. Today the Pavilion Hotel has been replaced with the Grand Burstin Hotel and the sluice gate has a café built upon it, but is currently vacant.

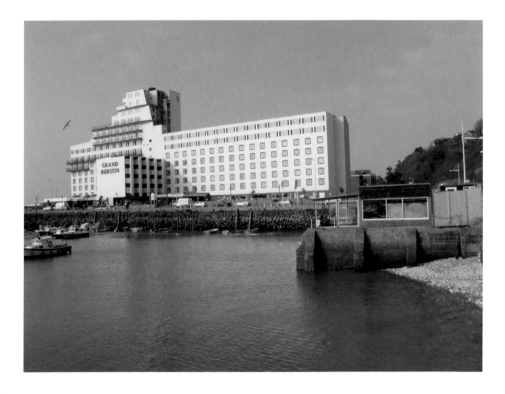

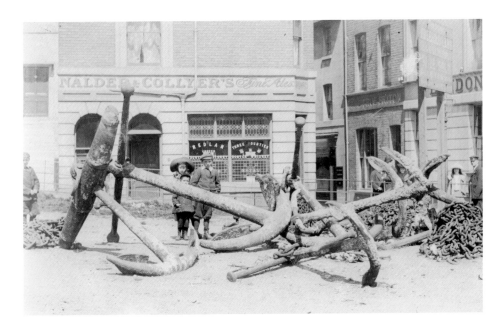

The Entrance to South Street.

This is the Anchor Yard where anchors lost from sailing ships were deposited when they were fished up from the sea. Sailing ships which had lost their anchors could purchase one from this yard. The building in the background is the Princess Royal, erected by Nalden & Collyer in 1862-3, but there had been an earlier Princess Royal, formerly known as the Engine Inn, on the same site. The present day picture shows that french doors have been introduced to allow access to the tables and chairs for those people wishing to sit outside.

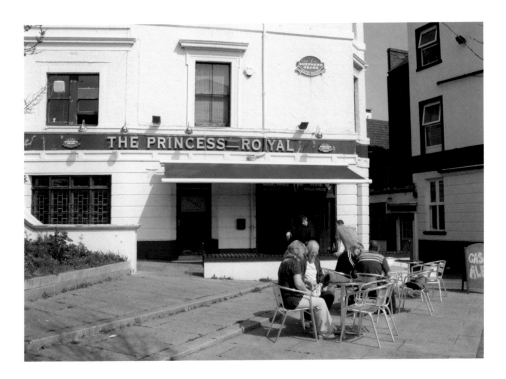

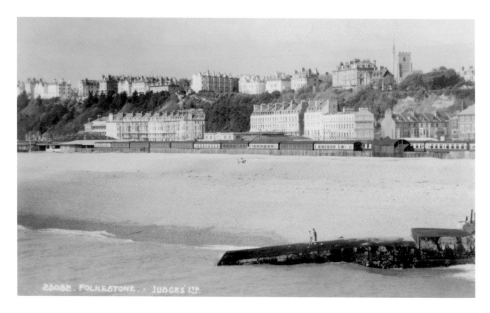

The Sea Front.

In this 1950s view can be seen the railway sidings, Marine Crescent, Marine Parade and the Leas. The railway sidings were used to park and clean carriages that were not in use. Some of the tracks were taken up in the early 1950s and those remaining in 1961 when the railway was electrified. The view of Marine Crescent and Marine Parade are obscured in this present day picture by a freight shed which was built on the site of the railway sidings and the disused Trinity House Pilot Station.

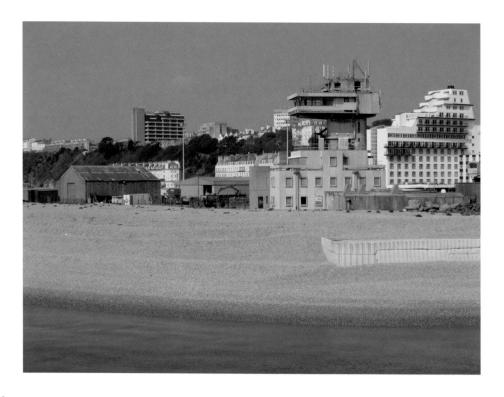

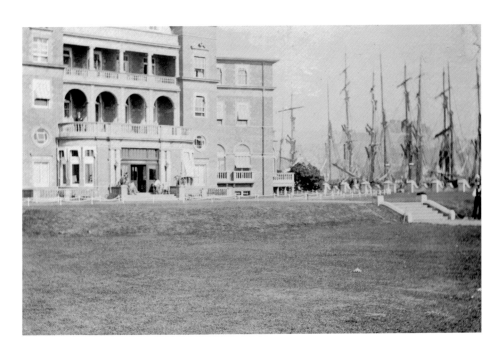

The South Facing End of the Pavilion Hotel.
One of the entrances to the Royal Pavilion can be seen opening onto the grounds, while in the inner harbour there is a maze of masts belonging to the sailing ships which were unloading their cargoes of coal, timber or ice. Today the rear of The Grand Burstin, built out to the pavement in the 1980s, obscures views of the harbour.

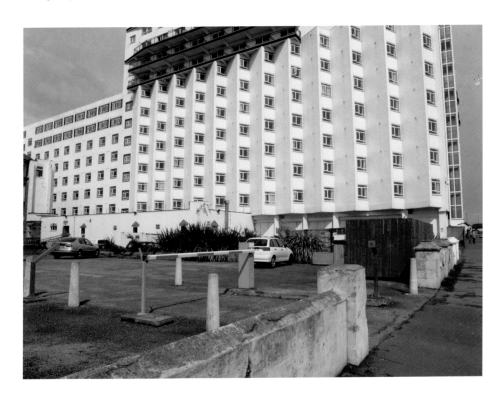

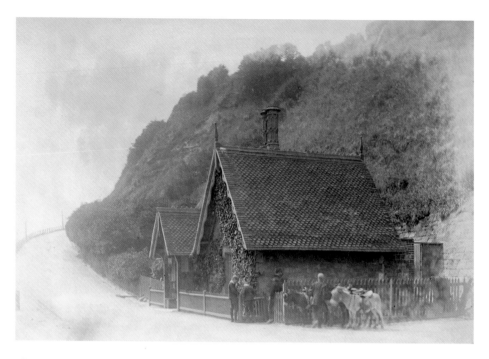

The Road of Remembrance, formerly known as the 'Slop Road.'

This photograph taken in August 1893 shows Swiss Cottage at the bottom of the Road of Remembrance. It was built for the turnpike toll, and, after the turnpikes were abolished in 1877, it was occupied by council workers until it was demolished in 1977. It is interesting to note the donkeys and ornate chimneys. Nothing much has changed in this present day picture apart from the absence of Swiss Cottage.

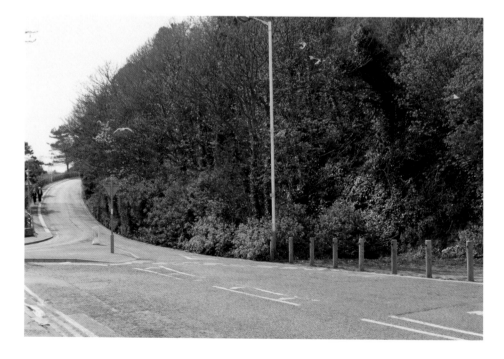

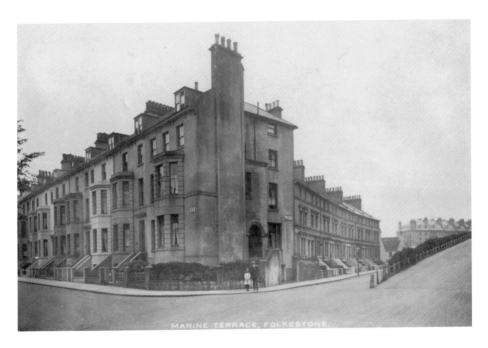

MARINE TERRACE, FOLKESTONE.

Lower Sandgate Road, looking west.

A nice peaceful scene at the junction of Marine Terrace and Lower Sandgate Road, *c.*1916. Just two people, a man and a girl, can be seen standing on the corner. The present day view shows that the houses in the Lower Sandgate Road are missing. They were demolished during enemy action in the Second World War.

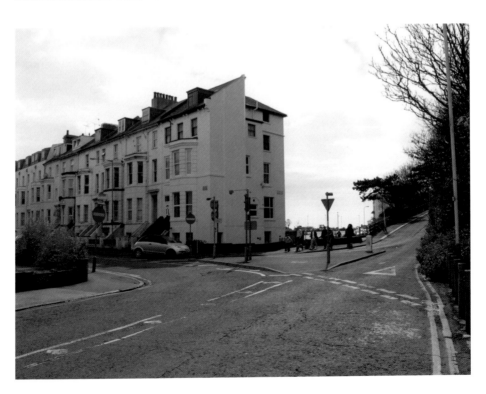

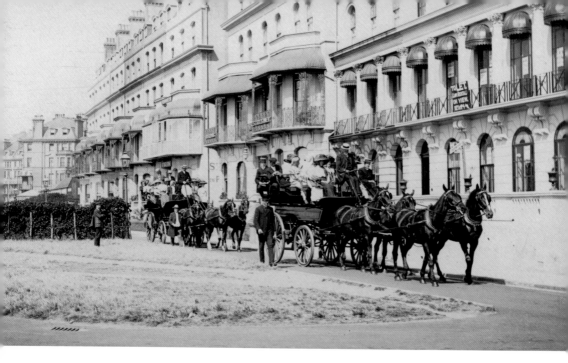

An Outing from Folkestone.

Two of Frank Funnel's four-horse coaches are seen here in Marine Parade about to leave for an outing, possibly to Canterbury. In 1914 the fare was 10s return, plus 2s 6d. each way if you wanted a converted box seat next to the coachman. Not much has changed to these mid-Victorian properties today except some of the canopies are now missing. The sub-tropical plants and palm trees were planted in 1992.

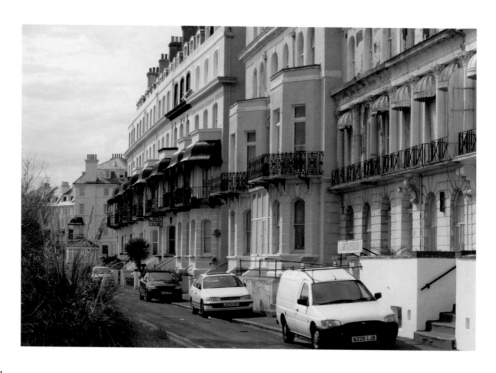

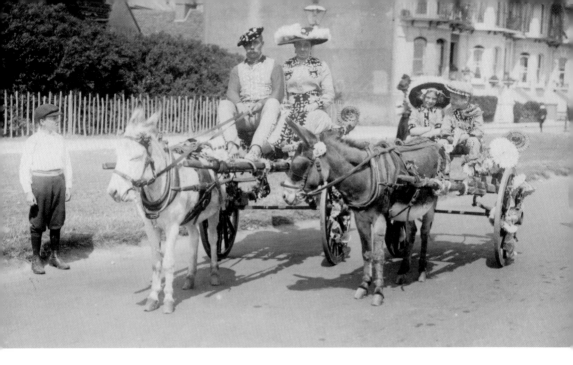

A Donkey Race during the War.

On the left can be seen Mr and Mrs Hollands driving Mr W. Pilcher's donkey Jenny. Next to them is Mr 'Channel' Gautier's cart. Named 'Channel' as he came from the Channel Islands, he sold fish from a cart and had a Fish and Chip shop in Marshall Street. Mr Pilcher's donkey cart was used for hauling produce down from his allotments and piggery at Wood Avenue to his house in Greenfield Road. The picture was taken in the Lower Sandgate Road. Behind the trees on the left-hand side was Tolputt's Timber Yard, currently a car park as can be seen here in the present day picture.

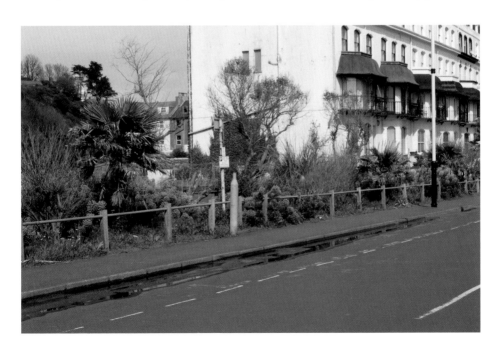

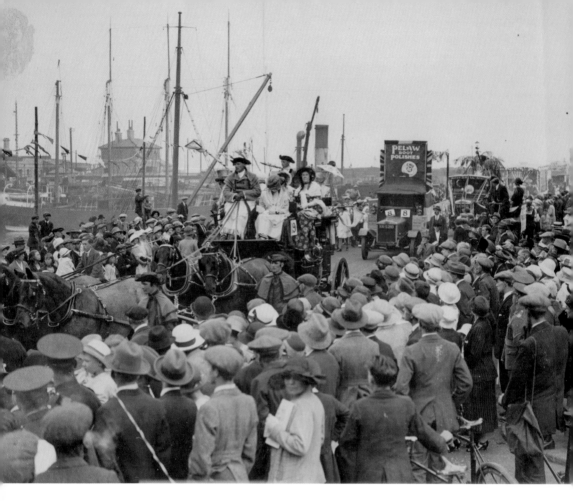

A Fancy Dress Carnival Procession in aid of the Royal Victoria Hospital fund, 25 June 1924.

Acknowledgements

Peter Hooper, Jakky Elvyi, Mrs Spicer, Robert Bailey, Brenda Reed,
Eamonn Rooney, Henry Rolfe, Mrs Mann, Tony Hill, H.W. Baldock,
Peter Bamford, Dora Alker